BLACK AMERICA SERIES
# BALTIMORE

# BLACK AMERICA SERIES
# BALTIMORE

Philip J. Merrill and Uluaipou-O-Malo Aiono

Copyright © 1999 by Philip J. Merrill and Uluaipou-O-Malo Aiono.
ISBN 0-7385-0132-8

Published by Arcadia Publishing,
an imprint of Tempus Publishing, Inc.
2 Cumberland Street
Charleston, SC 29401

Printed in Great Britain.

Library of Congress Catalog Card Number: 99-63433

For all general information contact Arcadia Publishing at:
Telephone 843-853-2070
Fax 843-853-0044
E-Mail arcadia@charleston.net

For customer service and orders:
Toll-Free 1-888-313-BOOK

Visit us on the internet at http://www.arcadiaimages.com

# Contents

| | | |
|---|---|---|
| Acknowledgments | | 6 |
| Introduction | | 7 |
| 1. | Entertainment | 9 |
| 2. | People of Iron | 27 |
| 3. | Education | 43 |
| 4. | Churches and Landmarks | 65 |
| 5. | Business and Labor | 75 |
| 6. | Men of Action | 89 |
| 7. | Instant Relatives | 103 |
| 8. | Lifestyles | 111 |

# Acknowledgments

We at Nanny Jack & Company are truly indebted to many individuals who provided assistance in piecing together this Black Baltimore photographic puzzle. We thank Kinko's Catonsville Copy Consultants Edwin Hopkins, Jeremy Schwaderer, Todd Jones, and Patrick Ellison; the staff at Macedonia Baptist Church Archives; Ralph Clayton and Eva Slezak of the Enoch Pratt Free Library; Herb and Shirley Weimer of The Squirrel's Nest; Dennis Milecki; David Donovan of the Bowery Antiques; Mike Haney; John's Antiques; Charles "Woody" Woodford; James T. Dorsey; Olivia P. Dixon; Roberta C. Keets; Monroe S. Frederick II; Joan and Herb Scurlock; Paul Roeger; Sonia Bontemps; Courtney Wilson; Mary Ellen Hayward; Ross J. Kelbaugh; Jerry Day; Jay Grubb; our intern Brooke Crittendon; the BMRES staff (Tien Tran, Mindy Martinez, Lana Belyavsky); and the rest of the Human Development Institute family, especially George and Betty Merrill. To those whose names should be included in this list, but are not, please forgive us for the oversight. You know who you are, and we thank you, too.

# INTRODUCTION

*Let us not be weary in well-doing, for in due season we shall reap, if we faint not.*
*-Book of Proverbs.*

In compiling the photographic materials and research for this book, the authors were overwhelmed by the many worthy yet untold stories about the struggles and triumphs of African Americans in Baltimore, from the pre-Civil War period to the present day. The images in this book were painstakingly selected from a larger collection amassed in the Nanny Jack archives over the last decade. The photographs, gleaned from antique stores, auctions, estate sales, flea markets, the Internet, friends, and garbage cans, each shouted their own tale. In instances where some voices were not as strong as others, we had to rely on clues found within the photographs. These clues included the photographer's name and studio address, the style of dress worn, any identifying marks on the reverse sides of pictures, or information provided by antique dealers who acquired the photographs from estate sales. In a few fortunate cases, the memories of people who remembered and could identify the people, places, and events photographed provided invaluable information.

Black photography is gaining in popularity across the country for its importance in completing the American history puzzle. Unfortunately, this also makes the acquisition of these items more expensive and difficult to find, as museums, collectors, and other institutions scurry to augment their collections. For too long, African Americans have been derided in their capacity to exist as thinking human beings and have been considered capable only of menial tasks. The photographs in this book clearly contradict this erroneous thinking. This book is not intended to be a comprehensive study of African-American life in Baltimore, but merely a window into the past experiences of those who came before, and their legacy. We hope you enjoy these images that have never before been seen by the public. We encourage you to collect, preserve, and cherish African-American history through photography.

# One
# ENTERTAINMENT

On her visits to Baltimore, Billie Holiday (1915–1959) sang at a variety of nightspots, including the Club Astoria. It is said that when Billie performed, she demanded absolute attention from her audience. No one was permitted to talk during her performances, or else! On one occasion, a patron ordered a drink while she sang. Billie stopped midstream, climbed down from the platform and strode to stand arms akimbo beside the patron. She tapped his shoulder, and as he turned said, in a loudspeaker voice: "I guess your mama weren't no lady!" It is generally believed that Ms. Holiday was born in Baltimore, but she was not. She was born in Philadelphia, in 1915, as Eleanor Fagan. Billie's nickname, "Lady Day," was given to her by her saxophonist, Lester Young. Young started out playing in the Count Basie Orchestra. A statue and park named in her honor are located on Pennsylvania Avenue between Lanvale and Lafayette Streets in Baltimore. The autograph on this 45 rpm record jacket reads as follows: "For Shirley stay happy, Billie Holiday." An enlarged reproduction of this cover is on permanent display in the window of the Rite-Aid pharmacy, located on Lexington and Howard Streets. When Billie Holiday joined Artie Shaw, she became the first black woman to sing with a white band. However, the partnership was short-lived as Billie buckled from the insults and prejudices she still faced as a "colored" performer.

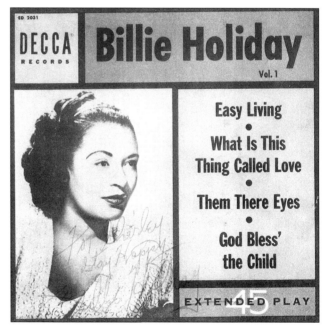

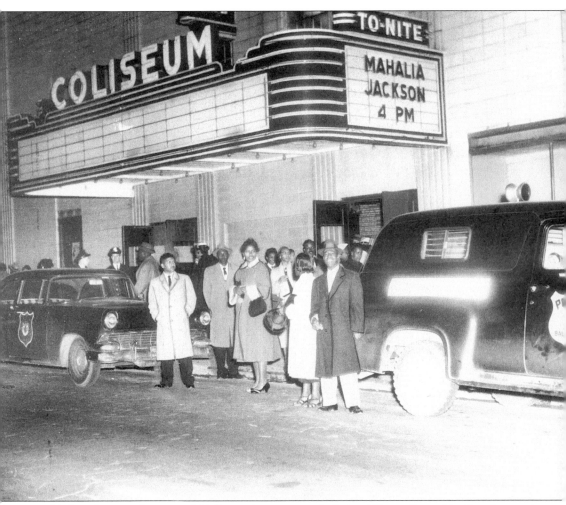

Today, the once-frequented Coliseum is an empty shell, but if its walls could talk, what stories they would tell! This scene is of concert goers who were disappointed by the nonappearance of Mahalia Jackson as scheduled. The police wagons outside were called to the box office when a crowd formed, demanding a refund on tickets, and became angry because no money was available. The Coliseum played regular host to fighting matches for boxers such as Joe "The Brown Bomber" Louis, wrestling bouts, and roller skating. Note that at this time, the Baltimore Police vehicles were still black and white. Today, the Baltimore City patrol cars are white, with blue stripes. This photograph appeared in the Baltimore *Afro-American* in November 1957.

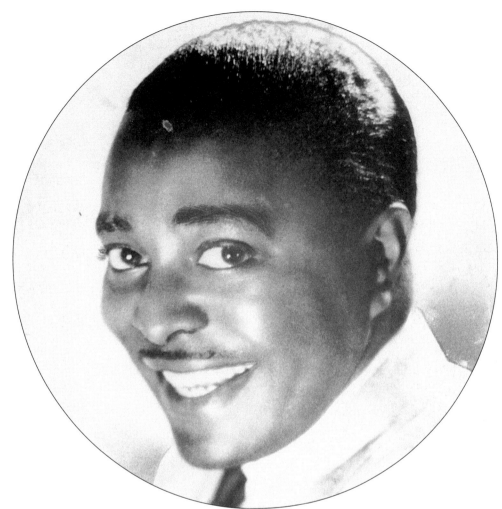

Rap music, which has earned itself a legitimate niche in modern music history, was actually originated by the slick looking gentleman pictured here, Louis Jordan (1908–1975). Referred to by popular rap artists as the "Father of Jump Blues," Jordan was spreading around his art in the 1940s, producing such familiar songs as "Is You Is, or Is You Ain't (Ma Baby)," "Beans and Cornbread," and "Saturday Night Fish Fry." The Broadway play *Five Guys Named Moe*, which toured in America and Europe, was based on Jordan's smash hit song of the same name. In 1956, Jordan, also affectionately called "Mr. Personality," and his band, the Tympany Five, led the Springtime Revue show at the Royal Theater in Baltimore, performing the hit song "Stone Cold Dead." During his headlining act Jordan's angry wife slashed him, and according to newspaper reports, he barely escaped with his life. Some of the labels on which Jordan recorded were Decca, Aladdin, Tangerine (owned by Ray Charles), and Mercury. Louis Jordan was inducted into the Blues Foundation Hall of Fame in 1983, and into the Rock n' Roll Hall of Fame in 1987.

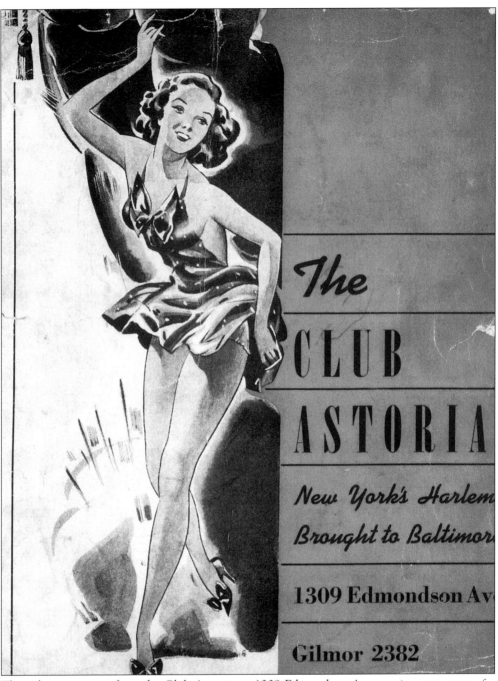

This a la carte menu from the Club Astoria, at 1309 Edmondson Avenue, is a memento of a bygone era. Touted as equal to the best of the black entertainment clubs in Harlem, the Astoria offered two floor shows nightly. The specialty item on Astoria's menu was Maryland Fried Chicken, while other menu items advertised were a "Half Fried Chicken" for 90¢, "Steak Sandwich" for 60¢, and "Spiced Ham Salad Sandwich" for 35¢. Club Astoria also boasted of a full house bar with imported liqueurs and champagne.

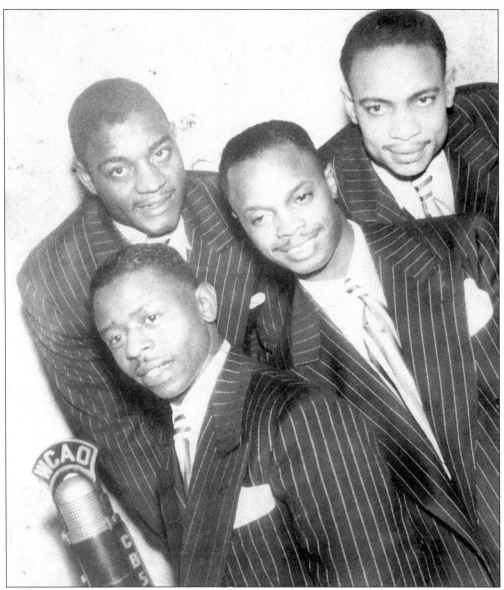

This unidentified group performed for Baltimore radio station WCAO (c. 1940s). They are uniformly sharp in their arresting pinstriped suits with matching vertical-striped ties.

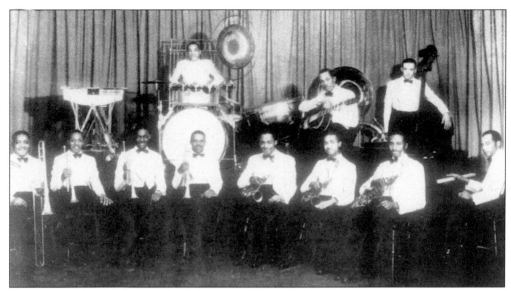

This is a mid-1930s photograph of drummer William Webb and his orchestra. A native son of Baltimore, William "Chick" Webb was not only famous for wowing crowds with his tympanic ability, but also for discovering vocalist Ella Fitzgerald. The group was originally called Chick Webb and His Chicks. On the front of the photograph is the following inscription: "Just me and Chick, Gordon Timets, Just me and Samson, George Charles, and "Jus me 'n left" Howard Williams. On the reverse of this image is a listing of 27 song titles played during an evening revue. Webb has been called one of the finest all-around percussionists of all time. He died in 1939, at Johns Hopkins Hospital and is buried at Arbutus Memorial Park.

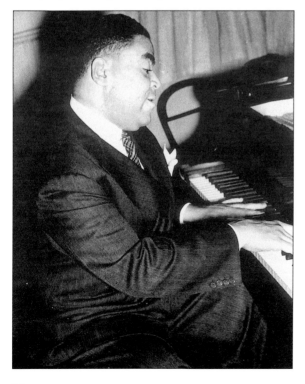

Thomas W. "Fats" Waller (1904–1943) is pictured here doing what he loved best: making and playing great music. This musical giant was headlined at the Royal Theater, on Pennsylvania Avenue, in the 1930s, as one of the hottest entertainment acts. Best known for his hit songs, "Ain't Misbehavin'," "Honeysuckle Rose," and "I've Got a Feelin' I'm Fallin'," Waller also starred in films such as *Hooray For Love*, *King of Burlesque*, and *Stormy Weather*. Born in New York, he attributed his love of music, style, and musical influence to his mentor James P. Johnson. During the 1920s, he started his own band and took it on national and overseas tours. Fats is remembered for his ability to bring the ivories to life, his animated expressions while performing, and his vibrant personality.

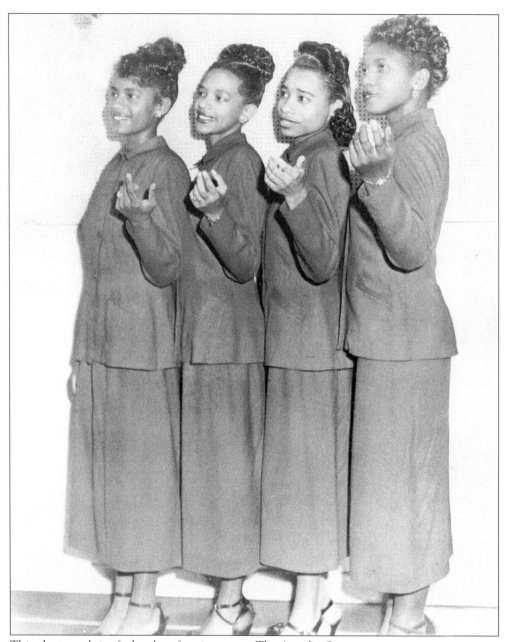
This photograph is of a local performing group, The Angelic Queens.

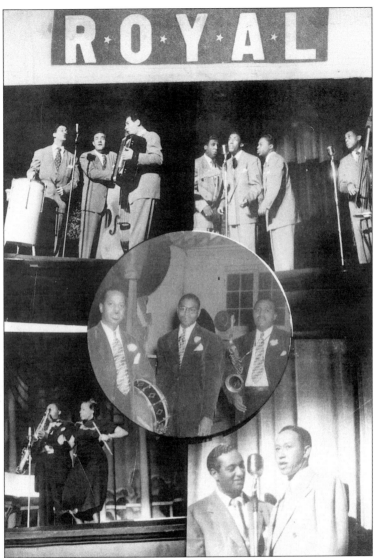

This unique collage offers a summary glimpse of some of the musical acts that were booked for engagements at the famed Royal Theater. Although many other fine establishments provided African Americans with live entertainment in Baltimore, it was generally thought that only the best acts performed at the Royal, which was on a par with the Howard in Washington, D.C., the Regal in Chicago, the Earl in Philadelphia, and the Apollo in Harlem. The Royal could seat up to 1,000 people, and at one time showcased movies, exhibitions, and vaudeville shows. The theater finally closed its doors in 1971, after showing its last double feature films *I Spit on Your Grave* and *Alley Cats*. On its former site now stands the Robert C. Marshall Elementary School. Some of the greats, who shaped music as we know it, played at the Royal, including Louis Armstrong, Nat King Cole, Count Basie, Duke Ellington, and Stan Kenton. Pearl Bailey appeared at the Royal in a chorus line-up, Jack Johnson gave a boxing exhibition on stage, Tracy McCleary was the house bandleader for 17 years, and saxophonist Charlie "Yardbird" Parker once served as a member of the orchestra. Pictured here are Pee Wee Wooten (center left) and Little Willie Adams (bottom right), with an unidentified gentleman from New York's Apollo theater. The rest of the people shown are unidentified.

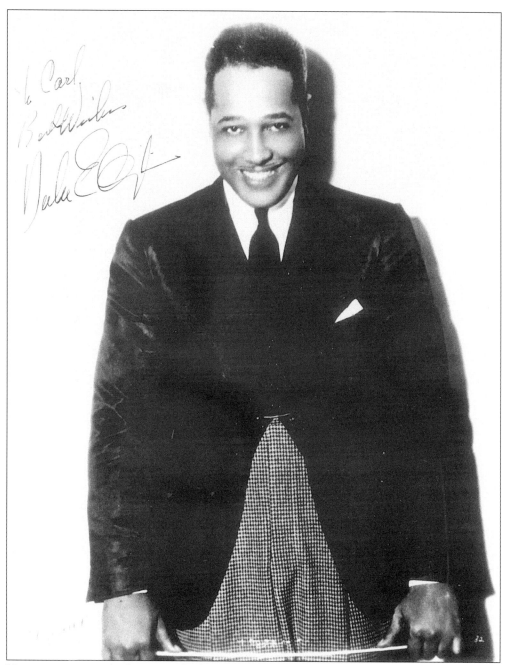

Here is an autographed picture of Edward Kennedy "Duke" Ellington (1899–1975). A world-renowned jazz bandleader, pianist, composer, and sketch artist, Ellington frequently performed at the Royal Theater. Some songs he is famous for are "Take the 'A' Train" (written by composer and pianist Billy Strayhorn), "Mood Indigo," and "Satin Doll." The year 1999 marks Duke Ellington's 100th anniversary, and events are being hosted worldwide to celebrate his life and legacy.

# SOUVENIR
# The Avenue Cafe
## 1550 Pennsylvania Avenue
### corner Pitcher Street

## DINE AND DANCE
## FROM 3 P. M. UNTIL 12 MIDNIGHT

William "Bill" Lindsay, Manager

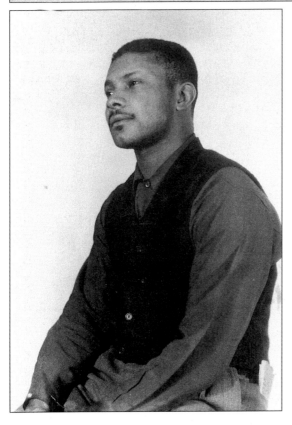

To commemorate the appearance of Todd Duncan, who performed as the original Porgy in George Gershwin's Broadway musical *Porgy and Bess*, the Avenue Cafe provided a souvenir photograph of Duncan, tucked inside an Avenue Cafe cover. The Café, which provided entertainment from 3 pm to 12 pm, was not open on Mondays.

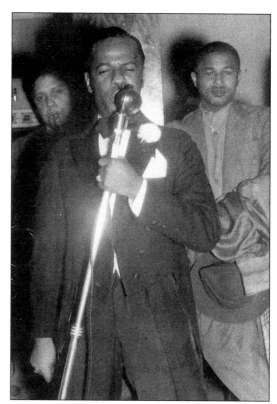

Gamby's, another Pennsylvania Avenue club, provided a similar souvenir photograph of Pee Wee Wooten and some of his band members. Wooten performed for radio, stage, and television around Baltimore as well as up and down the eastern seaboard.

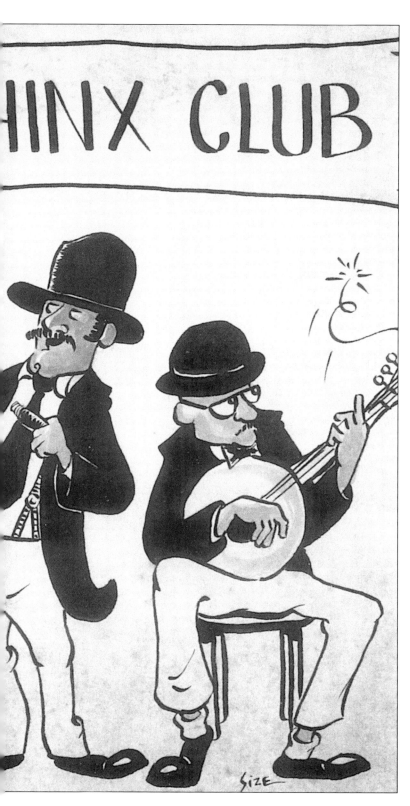

Next to the Royal, the Sphinx Club was one of the hottest places to be, whether you were a performer or patron. This original c. 1950s watercolor sketch of "Old Timers Nite" pokes fun at the owners of the club. In a humorous pose, one character holds a stethoscope to the bass and another helps himself to a drink from the same, while the banjo man twangs with a broken string. These characters are depicting Charlie Tilghman and "Doc" Woingust.

# SOUVENIR
# COMEDY CLUB
## 1414 Pennsylvania Avenue

### ENTERTAINMENT NIGHTLY

OLLIE WISE, Manager             IKE DIXON, Proprietor

Patrons at the Comedy Club, also on Pennsylvania Avenue, bask in the smooth tones of the sax.

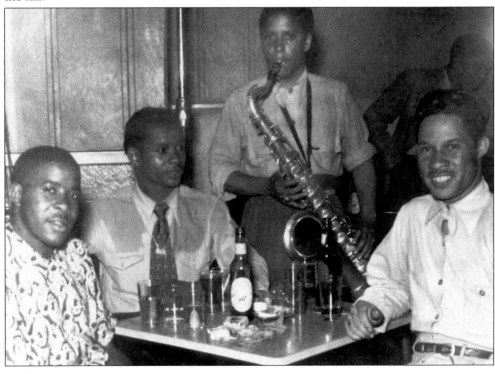

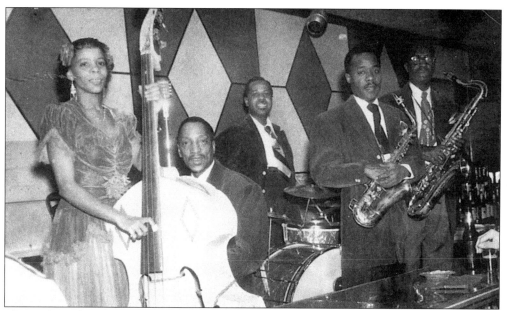

This is the only East Baltimore souvenir in our club lineup. This musical ensemble was at one time named the Pee Wee Wooten Trio, and at another the Three Kings and a Queen. Unusual in this photograph is the woman bass player.

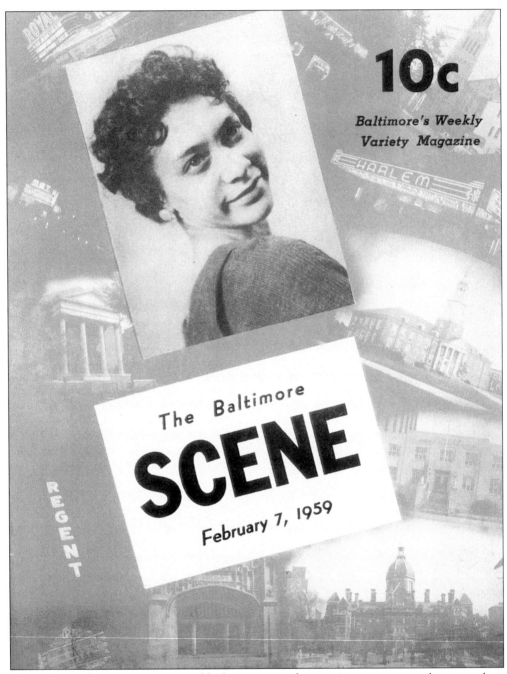

The *Baltimore Scene* was a compact, black activity guide covering events around town such as entertainment, sports, political, and fashion. Published at 2239 North Fulton Avenue, this weekly magazine sold for 10¢. The front cover, presented here, shows model Betty Smith, a student at Cortez Peters Business School, who aspired to be a stenographer for the federal government. Her hobbies were dancing and reading. Also featured on the cover are various shots of the nightclub buildings around Baltimore where African Americans sought escape.

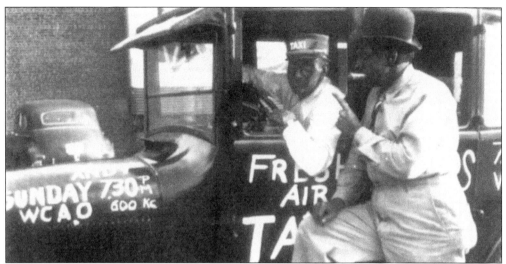

*Amos n' Andy* was one of the longest-lived radio comedy serials in history. Created by and starring two white men, Freeman Gosden and Charles Correll, the show first aired in Chicago in 1928. The show perpetuated stereotypes about African Americans, depicting them as being inferior, lazy, dumb, and dishonest. Black doctors were portrayed as quacks and thieves, while black lawyers were slippery cowards. Nonetheless, these fictional characters endeared themselves to both white and black audiences in the 1930s. Amos was painted as a gentle soul who drove the "Fresh Air Taxicab." He did most of the work, while Andy was characterized as devious, bossy, and better suited to "supervising" Amos. By 1947, the program was rated the fourth most popular broadcast show. Interestingly, when the show was produced for television media, black actors were cast as Amos and Andy, as well as other character roles. In the 1950s, the National Association for the Advancement of Colored People (NAACP), together with other groups, voiced strong objections to the negative messages perpetuated by the show. They pressured the broadcast industry to remove the program from the air and won. In this c. 1940s image white actors, in black face, are portraying Amos and Andy for Baltimore radio station WCAO.

William "Count" Basie (1904–1984) autographed this stub of a ticket to a performance he and his orchestra gave at Andrews Air Force Base in Maryland. Before beginning his own band in 1936, Basie studied under the tutelage of Benny Moten, who founded the Kansas City Movement. Count Basie often performed at clubs on Pennsylvania Avenue, where patrons flocked to listen and dance to his distinctive sound, which gave rise to swing music. In 1957, the Count Basie Orchestra was the first American band to play at a royal performance before Queen Elizabeth II of England.

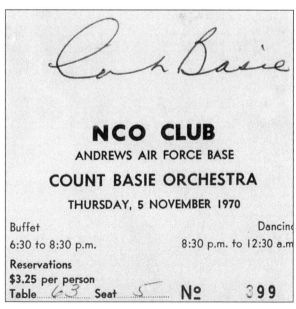

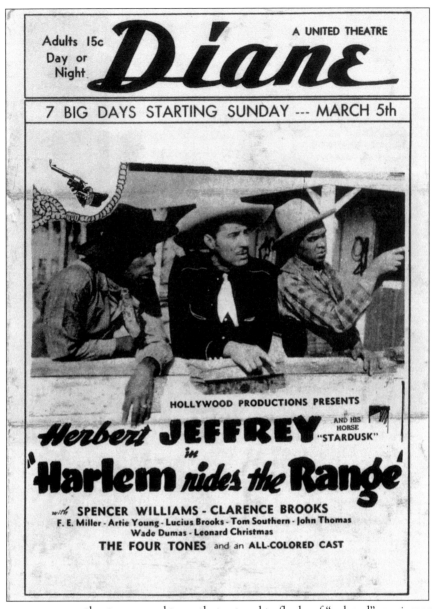

There were numerous theaters around town that catered to flocks of "colored" moviegoers. The Diane was built by the Hornstein family in 1935, and seated 500 patrons. Located at 421 Pennsylvania Avenue, this movie house was part of the United Theater empire, which distributed "play pictures" or motion pictures. In this stunning c. 1940s program, Spencer Williams (left), Herbert Jeffrey (center), and Clarence Brooks (right) star in the Hollywood production *Harlem Rides the Range*. Of special interest is the advertised "all-colored cast." Some of the other theater houses where blacks spent their dollars were the Roosevelt, Lincoln, Hippodrome, Met, Carver, Apollo, and Royal. The Royal opened for business in 1926, replacing the Douglass Theater that stood on the same site. The Douglass began in 1922, and proudly billed itself as owned and operated by coloreds. This above list of "colored" movie theaters is by no means exhaustive. These institutions evolved during a time when blacks endured the bigotry of Jim Crowism.

# Two
# PEOPLE OF IRON

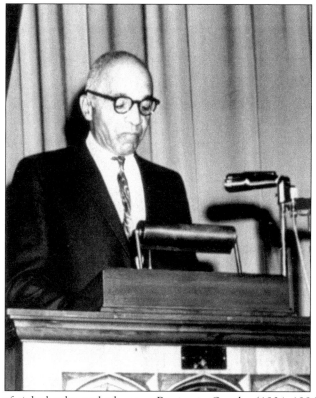

Historian, author of eight books, and educator, Benjamin Quarles (1904–1996) was a longtime professor of history and chairman of the History Department at Morgan State College. Now called Morgan State University, the school houses the Quarles Collection, which includes his personal papers, books, letters, and historical items. This photograph was taken in the fall of 1968. In the following year, his critically acclaimed work, *Black Abolitionists*, was published, in which Quarles documented many important achievements of free blacks. As time passes, appreciation grows for Quarles' in-depth scholarship.

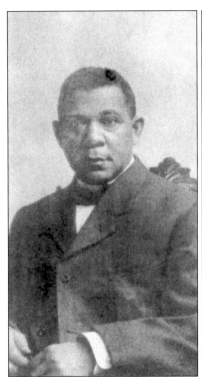

```
                                BOOKER T. WASHINGTON
                                TUSKEGEE INSTITUTE, ALABAMA
                                        March 28, 1910
    Personal

    Mr. J. H. Murphy,
        c/o Afro-American Ledger, Baltimore, Md.
            My dear Mr. Murphy:-
            Permit me to thank you most heartily for the generous
    manner in which you treated the appeal for endowment for
    Tuskegee. It was very kind of you to display it in the
    way that you did on your front page.
            I hope at some time I will be in a position to repay
    you for some of your many and constant acts of kindness.
                                Yours very truly,
        H                       [signature]
```

Booker T. Washington (1856–1915), the founder and president of the National Negro Business League, attended a branch meeting of the League in Baltimore in 1903. This letter was addressed to John H. Murphy, at the Baltimore *Afro-American Ledger* (predecessor to the *Afro-American* newspaper), thanking him for his support of Tuskegee Institute, which Washington headed. He served in this capacity until his death in 1915 (five years after the date of this letter). His best-selling autobiographical work, *Up From Slavery*, was published in 1900. Like other cities across the country, Baltimore has a school named after this eloquent orator, author, and educator (see page 58). This rare photograph was deposited with a company that specialized in pin-back buttons, pamphlets, and other published materials for reproductions, but was never retrieved by the owner. On the back of the picture is written "Return to E.M. Howell, No. 7 1/2 Wall St., Atlanta, GA." (The company went out of business in the mid-1950s.) Coincidentally, Howell lived in the same state where, in 1895, Washington rendered his most famous speech, the "Atlanta Compromise," as part of the Cotton International Exposition. Robert W. Coleman, publisher of the *First Colored Directory of Baltimore* and a comrade of both men, described Washington as "the Moses of the race," and said of Murphy ". . .he was the Dean of Newspapermen in the U.S."

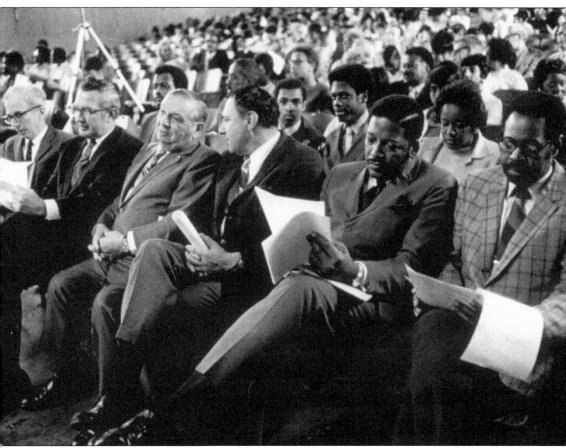

Robert Douglass (front row, fifth from left) is shown here attending the 1970 assembly at Paul Laurence Dunbar High School. From 1967 to 1974, Douglass was a City Councilman representing the 2nd council district in East Baltimore, where his alma mater is located. From 1975 to 1982, Douglass served in the Maryland State Senate and returned to the City Council in 1995, after being out of office for more than a decade. (Joe Didio of the National Education Association, photographer.)

In 1853, George Wright, a free man of color, was wrongfully seized by slave traders B.M. and W.L. Campbell and Marcy Fountain. He was thrown into a private jail for slaves operated by the Campbells, on Pratt Street in Baltimore. During the mid-1800s, the Campbells, who owned the largest slave-trading business in Baltimore, operated a branch office in New Orleans, where most of their "fresh" merchandise (runaways or suspected runaway slaves) were caught. The following is a brief excerpt of the petition of appeal to Judge William L. Frick of the Superior Court to free Mr. Wright from his dilemma:

"To the Honorable William Frick,

Judge of the Supreme Court for Baltimore

The petition of George Wright a free man of colour [sic] humbly represents that he is detained, held in bondage as a slave by Marcy Fountain and B.M. and W.L. Campbell, and that he is now actually confined in the jail a place of confinement for negroes in Pratt Street belonging to the latter, and that he is credibly informed and apprehends that they are about to sell and remove him from the State of Maryland as a slave for life. He therefore humbly prays that a subpoena addressed to the said Marcy Fountain and B.M. and W.L. Campbell to appear in your Honorable Court on a day to be therein named and further your petitioner prays to not be moved from the jurisdiction of the court."

–Nolan Poe
Atty for petitioner

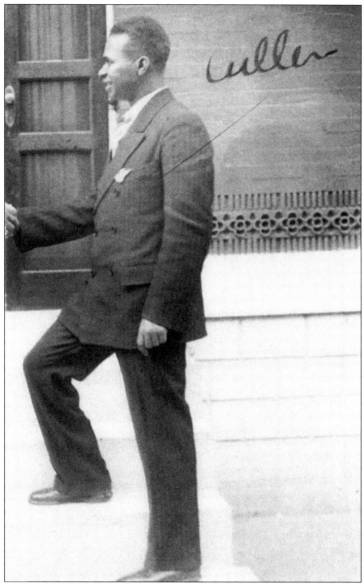

Countee Cullen, shown here on one of his rare visits to Baltimore, became one of America's most famed black poets. In 1925, he wrote a piece about an experience in Baltimore as a young boy who left an indelible print on his memory. This poem describes the racial discrimination experienced by generations of African Americans:

>Once riding in Old Baltimore,
>Heart-filled, Head-filled with glee,
>I saw a Baltimorean keep looking straight at me.
>Now I was eight and very small, and he was no whit bigger;
>And so I smiled, but he poked out his tongue,
>And called me "Nigger."
>I saw the whole of Baltimore from May until December;
>Of all the things that happened there,
>That's all I remember.

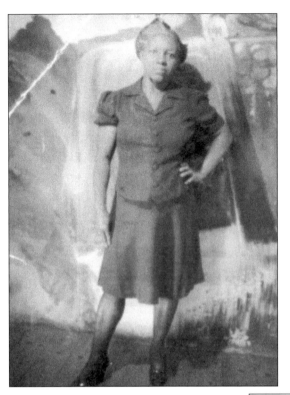

This august woman is Gertrude B. Jackson, better known as "Nanny Jack," the great-grandmother of the author. Hailing from Charles Town, in West Virginia, she resided in Baltimore's Sandtown-Winchester district (at 1307 N. Stockton Street) for almost 40 years, living to the ripe old age of 98. The first part of her nickname, "Nanny," originated from her profession as a midwife, and "Jack" was the derivative of her last name. A tower of strength in the community, she could be depended on for advice, money, food, shelter, and a good spanking when one was deserved. Nanny Jack was a frequent visitor to the Pennsylvania Avenue entertainment spots, and was well known to many of the performers who came to town. She is photographed here in this "I'll take no prisoners" stance at either Brown's or Penn Studio in Baltimore.

Dr. Herbert Frisby autographed this four-page publicity card (copyright 1969). Born and reared in a slum section of Baltimore, Frisby worked his way through high school by selling peanuts in alleys and on streets after school. He graduated from the Colored High School in the class of 1905. Frisby worked his way through college and graduate studies at Howard, Columbia, and New York Universities, as well as other graduate programs, by playing in jazz orchestras on weekends and during summer vacations. He eventually returned to the Colored High School to teach biology. Credited in the history books with being the "second Negro to go to the North Pole," Frisby spent 40 years rallying to have a memorial placed on the North Pole in honor of his idol, Matthew Henson, and he accomplished this feat on August 13, 1956. Frisby made 25 trips to the Arctic regions, focusing on projects honoring arctic explorer Henson's achievement.

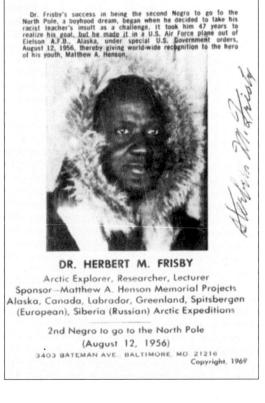

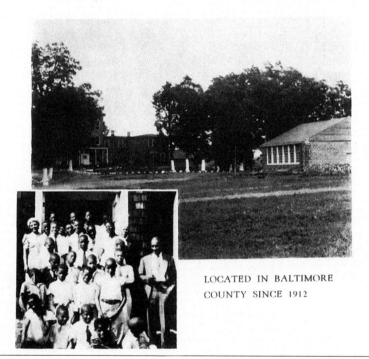

The Reverend George F. Bragg, Jr., D.D., a giant among black Baltimoreans in the first half of the twentieth century, is barely remembered today. Bragg, a tireless educator, community activist, scholar, and publisher, dedicated his life to helping those less fortunate than himself. In the next series of photographs, the magnitude of the Reverend Bragg's legacy is self-evident. Reverend Bragg founded the Maryland Home for Friendless Colored Children in 1899, to care for underprivileged African-American youth below college age. Originally started in Baltimore City in 1912, the home moved to its present site, a 32-acre tract in Baltimore County (in present-day Catonsville). Here, boys between 8 and 14 years old were instructed in academic, vocational, agricultural, and religious studies. In keeping with Bragg's belief in the importance of a well-rounded education, the boys also learned the home training they may have lacked due to economic or domestic poverty. The year 1999 marks the 175th anniversary of St. James Episcopal Church, at 1020 West Lafayette Avenue, for which the Reverend Bragg served as pastor for almost one half century (1891–1940).

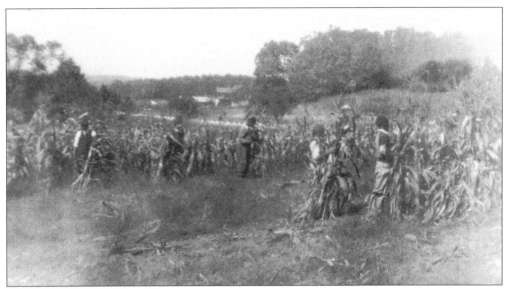
A handful of the boys are seen here, clearing the cornfield at Bragg's home. Half of the home's acreage was utilized for cultivation, which provided vegetables year round for meals. The boys also learned to raise hogs and poultry. Surplus eggs were sold on the market.

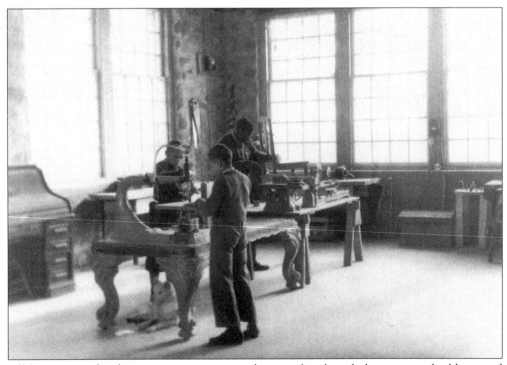
All boys received rudimentary instruction in the use of tools to help maintain buildings and equipment on the grounds.

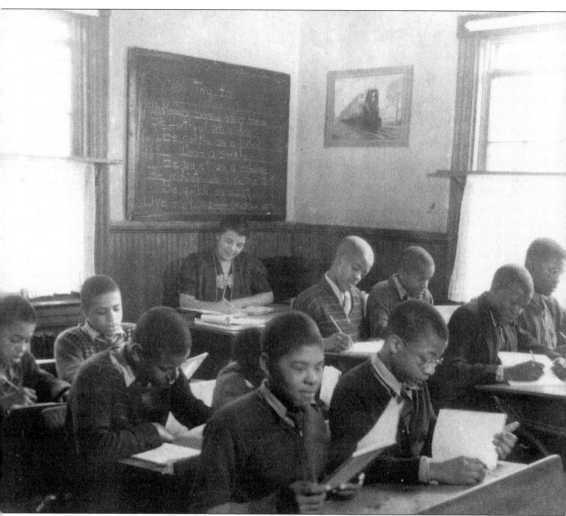

Bragg's calling was shaped during his early upbringing by his paternal grandmother, who had been a house slave to an Episcopal rector in Petersburg, Virginia. The blackboard, at the rear of the classroom, is a wonderful testimony to the caliber of young men that the Reverend Bragg and his helpers hoped to produce from time spent at the home. The text on the blackboard reads as follows: "Try to keep busy as a bee. Be faithful as a dog. Be gentle as a bird. Wear a smile. Be quiet as a mouse. Be industrious like an ant. Be quick as a cat." These lads were expected to master the basics of grammar and leave the institution with a strong grasp of elementary school training. Classes were divided into two groups: grades one through four and grades five through six. Students in grades five and six spent half a day working in the classroom and the rest training in the workshop, in the laundry, or working on the farm and caring for livestock. The academic work of the institution was prescribed by the Board of Education of Baltimore City.

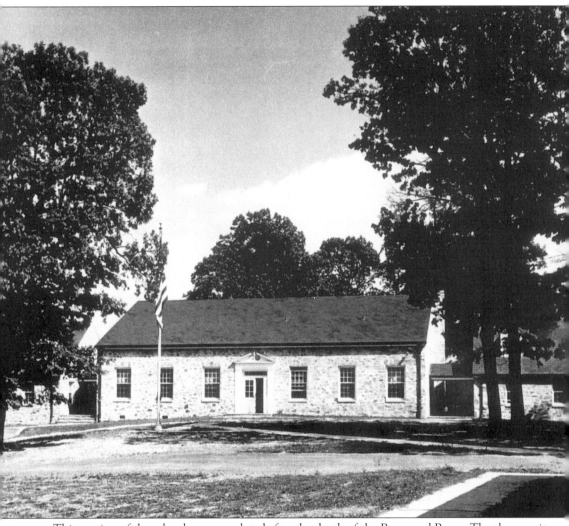

This portion of the school was completed after the death of the Reverend Bragg. The three-unit building was constructed with the aid of the boys at the home acting as stonemason's helpers. They were responsible for excavating the cellar and foundation under the guidance of Superintendent Harris and a stonemason. All of the stone for the buildings was dug out and transported across the grounds by the boys, reducing the cost of construction by two thirds.

World famous soprano Anne Brown was the sole sponsor of the festivities that launched the new U.S. Navy ship, the S.S. *Frederick Douglass*, at Bethlehem-Fairfield Shipyards in 1943. Brown, for whom playwright George Gershwin created the character of Bess in *Porgy and Bess*, was honored at a luncheon held after the ribbon-cutting ceremony.

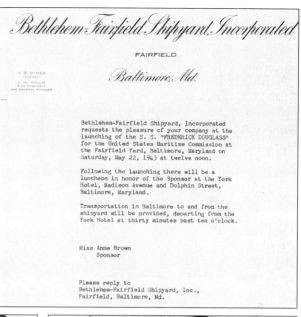

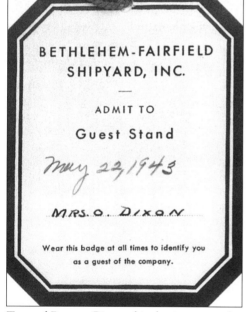

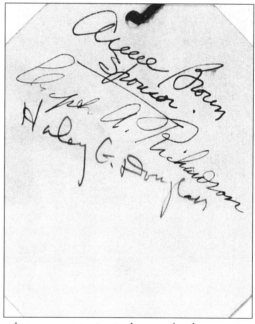

*Top and Bottom:* Pictured is the invitation letter that was sent to invited guests for the occasion "on Saturday, May 22, 1943, at twelve noon," and a guest pass that was worn by attendee Mrs. O. Dixon. The reverse of the guest pass is signed by Anne Brown, sponsor; Captain A. Richardson; and Haley G. Douglass (a descendant of Frederick Douglass). Anne Wiggins Brown was first acclimated to the world of performance as a youngster. At age five, she sang before a crowd of WW I soldiers at Camp Meade (now called Fort Meade). A *c.* 1920s Douglass High School graduate, Ms. Brown went on to prominence in the operatic world, but still maintains ties with her family and friends in the Baltimore area. In 1998, she traveled from her home in Norway to receive a prestigious award from Baltimore's Peabody Institute of the John's Hopkins University, in recognition of her lifetime achievements.

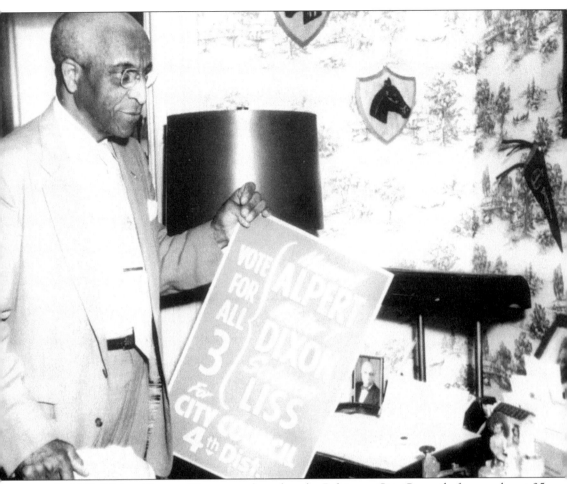

In 1955, Walter Thomas Dixon was elected to the Baltimore City Council after an almost 25-year absence of black representation on that body. An accomplished man even by today's standards, Dixon earned several university degrees. He was instrumental in aiding the integration of mental institutions and hotels in the state of Maryland and fought to have legislation enforcing entitlement of blacks to minimum wages. A co-founder of the Cortez W. Peters Business School in Baltimore, Dixon helped generations of African Americans become skilled in typing, stenography, journalism, and accounting. Known as a "race man," Walter Dixon is remembered by many as a gentleman who worked his whole life to improve the political and economic standing of blacks. Here, he is pictured with a political banner announcing his candidacy for election to represent the 4th district on the City Council. (Clinton's Studio, photographer; Baltimore, MD.)

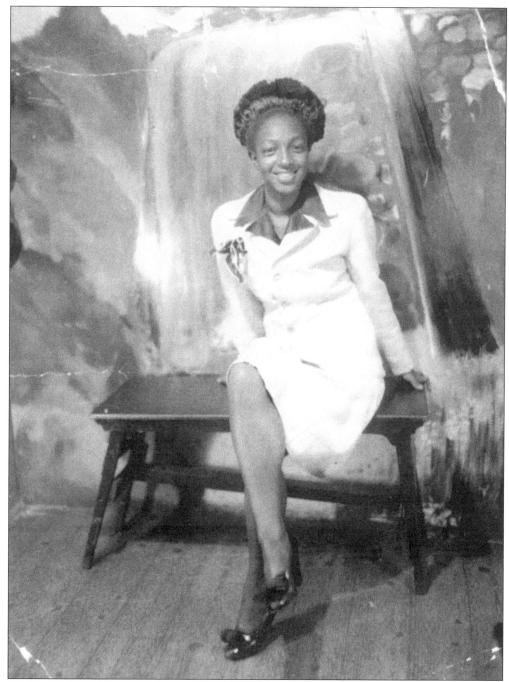

Meet the author's grandmother, Mary Frances Watkins (*née* Jackson), as she poses for an unidentified local photographer (*c.* 1940s). A resident of Baltimore's Sandtown-Winchester community in her early years, Frances later moved to Long Island, New York, where she completed her master's degree in social work. She has received many honors and other recognition for her long record of civil rights and community activism on Long Island.

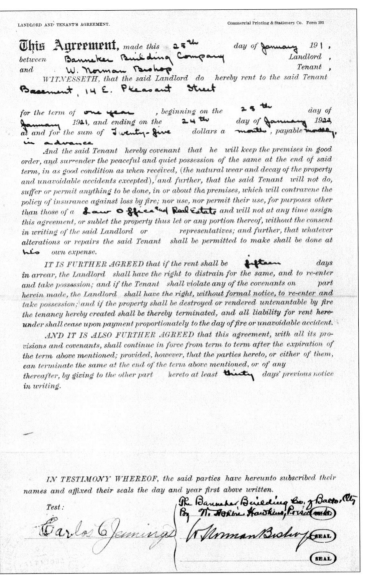

Attorney W. Ashbie Hawkins (1862–1941) led a distinguished career in Baltimore. It is reported that the majority of the student body of the University of Maryland Law School forced the ouster of Hawkins and another student by means of an anti-black petition in 1890. Hawkins then attended Howard University Law School, graduating in the class of 1892. He joined forces with another prominent attorney, George W.F. McMechen, in a flourishing legal practice. The partnership of Hawkins and McMechen was housed in the Banneker Building at 14 E. Pleasant Street, which was the first office complex erected solely for black professionals. This site was dedicated in 1903. The landlord and tenant's agreement, seen here, contains Mr. Hawkins's signature. According to this document, it appears that Hawkins is both the owner and the president of the Banneker Building Company. He is leasing office space to attorney William Norman Bishop (Yale Law School). Notary Public Charles C. Jennings, who was associated with the law offices of William C. McCard, affixed his signature to this document.

**EXECUTIVE COMMITTEE**

J. STEWARD DAVIS, Chair.
W. NORMAN BISHOP, Secretary
E. MAYFIELD BOYLE, Vice-Chr.
Wm. H. LANGLEY, Treasurer
MRS. JENNIE H. ROSS
MRS. H. E. YOUNG
MRS. HELEN COOPER
MRS. IDA HILTON
ARTHUR M. BRAGG
HARRY A. VODERY
HARRY OWENS
DR. WALTER JACKSON
CARL J. MURPHY
DR. THOMAS
LINWOOD KOGER
LEO STEVENS
WILLIAM PROCTOR
DANIEL RICHARDSON
TRULY HATCHETT
HUGH M. BURKETT

**STATE HEADQUARTERS**

**INDEPENDENT REPUBLICAN LEAGUE.**

1107 DRUID HILL AVENUE
BALTIMORE,        MARYLAND.

\* \* \* \* \* \* \* \*

FOR UNITED STATES SENATOR FROM MARYLAND
**W. ASHBIE HAWKINS**

Dr. A. B. Wilson,
Hagerstown, Md.,

My dear Dr. Wilson:- Your letter of the 5th inst. addressed to Mr. Davis, our chairman duly received and to hand. In reply I am directed to say that the twenty-ninth of October is an acceptable date and is hereby confirmed.

Yours very truly,

Secretary

WNB:RS.

This Independent Republican League letterhead indicates that Ashbie Hawkins was backed by a strong black contingent of civic supporters to campaign for a seat in the United States Senate (1920). As early as 1897, Hawkins was involved with the Independent Republican movement.

*The*

# FIRST COLORED

## Professional,

## Clerical,

## Skilled and

## Business

# DIRECTORY

—— OF ——

# BALTIMORE CITY.

WILLIAM N. BISHOP,
II CRESSON HALL,
LINCOLN UNIVERSITY, PA.

Robert W. Coleman, his wife Mary Mason, and their six daughters worked diligently to publish the *First Colored Directory of Baltimore City* from 1913 until Coleman's death in 1946, when all publication ceased. Often referred to as "the blue book" the *Directory* frequently provided biographical sketches of prominent black citizens of Baltimore. The *Directory* also had annexes in the cities of Washington, D.C.; Wilmington, Delaware; Annapolis, Maryland; and Wheeling, West Virginia. Coleman, who was blind, simultaneously established the Association for the Handicapped, which in later years became the Robert W. Coleman Foundation. For decades, the organization provided glasses for the sight-impaired and other supportive activities for African-American youth.

The "Prefix" of the first edition of the *Directory* reads as follows: "One would not imagine the work entailed in the compiling of a book of this character, especially for me as my time is so divided owing to the fact that the greater part of the day is devoted to learning my trade (Piano Tuning) at the Maryland Workshop for the Blind. I have tried to establish a method of a real effective medium of advertisement, and at the same time to collect a Directory of Colored, Professional, Clerical, Skilled and Business people. I am certin [sic] I have not reached all of them, but owing to the fact that such an undertaking is so broad in its scope, that it would entail a great expense and a number of clerical assistants to make it complete, therefore, I ask that the public will be charitable in their criticisms. I wish to thank my many friends for their kind favors in assisting me in the compiling of this book. Very respectfully, Robert W. Coleman." (Copyright by Robert W. Coleman [Coleman Printers] June 1913.)

*Three*

# EDUCATION

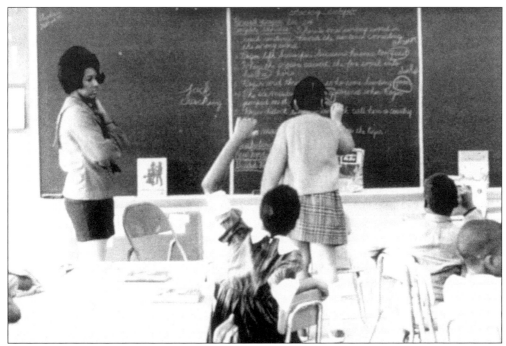

In 1968, the author's mother taught fourth grade at Johnston Square Elementary School Number 16, located at Valley and East Biddle Streets. Miniskirts, dresses, and high hair were in fashion at this time.

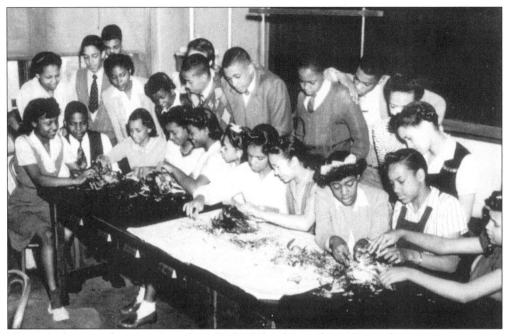

These biology students at Douglass High School Number 450 took part in a project investigating the marketing and selling of chicken broilers. Part of their assignment was to design and implement a scientific and humane method for killing the birds. Then the chickens were dressed and arranged attractively in student-devised containers for sale and delivery to customers. This was such a successful endeavor that the demand greatly exceeded the supply.

> Box 407
> Durham, North Carolina
> November 10, 1939
>
> Dear Walter,
>
> You know you would have seen me as I passed through on my way home, had it not been for the terrible weather that I ran into, and I was already late getting back.
>
> Good luck to you and Mr. Ammons, and I hope your publicity will be in full swing before long. I am sure that you will have a huge success of it. Maybe you and my publishers will get together soon. I hope.
>
> Yes, the Morgan College conferred the degree of Dr. Litt. D., upon me last June. I'm sure that I will have much publicity, now that you know.
>
> Tell Chinky that I want her to come down and stay with me for a long time. Tell her that I will take the house if she comes. It is three miles from the campus. I don't see why we can't get together for Thanksgiving. Anything you plan will be all right with me.
>
> My new book was off the press November 9. I will give you the dope on it very soon, and I know you will see that it gets plenty publicity on that end.
>
> Write again real soon.
>
> Most lovingly,
> Zora

This is a rare piece of correspondence penned by prolific African-American folklorist and writer Zora Neale Hurston. In this personal letter, she writes to Walter T. Dixon (co-founder of the Baltimore branch of the Cortez W. Peters Business School) and his wife Olivia (nicknamed "Chinky"), exchanging news. As evidenced by the content, the Dixons and Hurston maintained a close relationship.

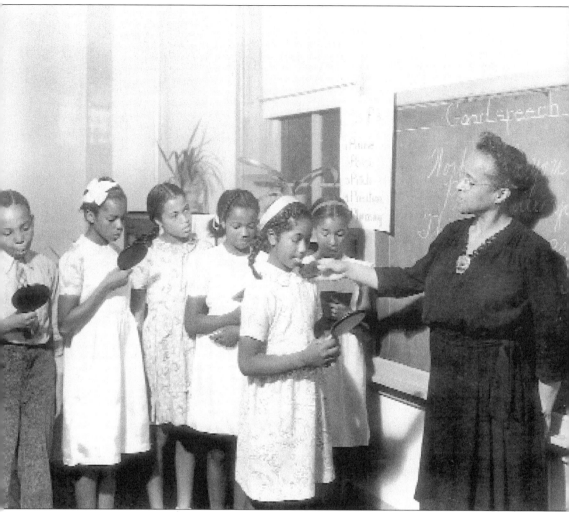

Six special education students (grades four through six) pay close attention to the public speaking instructions from their teacher, Miss Seally. On the chalk board at Gilmor Elementary School Number 108 (Gilmor and Presstman Streets), the five "Ps" (pause, poise, pitch, position, and phrasing) are displayed. (Hughes Co. photographer.)

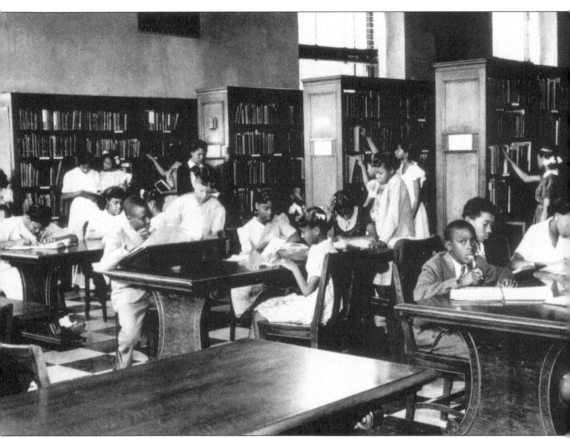

Since its inception in 1933, the central branch of the Enoch Pratt Free Library, on Cathedral Street, has seen thousands of students struggle with assignments, conduct research, and read for leisure. In this photograph, students are investigating literary resources as part of their class assignments. Some of the same tables, chairs, and bookcases pictured here are still in use on the first floor of the library. The Enoch Pratt Free Library continues to serve as a state resource, providing library tours to school groups, guiding interested parties in research, hosting book signings by authors, and providing occasional exhibits.

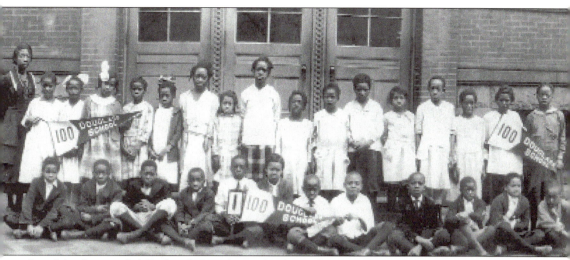

Inez Moody attended Frederick Douglass School Number 100 through the eighth grade. Her report cards for second grade in 1920, and seventh grade in 1925, indicate that she had perfect attendance, was hardly ever late, and was a pretty good student. Inez's first grade teacher was Cecelia E. Conner (a practice teacher), who resided at 3116 Barclay Street. Her second grade teacher was Carrie M. Smith, who lived at 1321 Argyle Avenue.

African Americans attended segregated public schools until 1954. In Baltimore, the black public schools were numbered 100 and upwards, such as Frederick Douglass School Number 100. In 1923–1924, Elmer A. Henderson was the acting principal at Frederick Douglass.

Pictured here is a group of school children on their way to Washington, D.C., in 1913. Knickers were the dress of the day for young boys, and girls wore lace dresses with large bows in their hair. Two of the children (front row) have interesting armbands with a leaf motif on their left arm. Some pupils (second row, fourth and seventh from left; back row, second from left) have black bands on their left arm, perhaps to denote the difference in grade level or activity groups. The young man leaning on the left wall in the picture is seen as an adult in the next photograph.

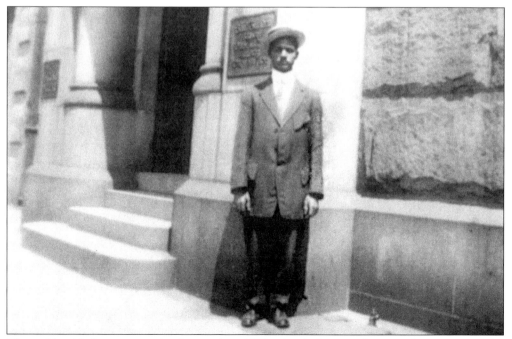

The unidentified young man in the previous 1913 school photograph is seen here, as an adult, at the entranceway to a building.

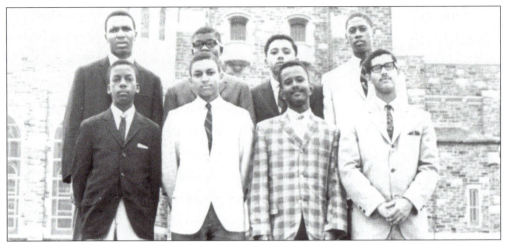

This photograph, taken during the 1960s, shows a group of City College students. At that time, the school only served boys. City College, established in 1839, was the first secular school in Baltimore. Shown here, from left to right, are as follows: (top row) Michael Edmonds, Ivor Edmond, Roland Ganges, and Carroll Johnson; (bottom row) Darrel Gray, Grafton Matthews, Herbert Frisby Jr., and Robert Rea Jr.

Edmondson High School, now called Edmondson-Westside High, serves predominantly black students, but in 1958, as this team photograph shows, the school was racially mixed, with a white majority likely. These basketball players are being prepped on strategies by the coach, who uses chalk drawings on the floor to demonstrate tactical moves. The boys' uniforms predate the elasticized waistband boom, as they are wearing belts looped through the waistband. This picture was featured in Edmondson High's 1958 Yearbook, *The View*.

In 1965, Frank Hennessy of the National Brewing Company presented brothers James (Carver High) and Royston Jackson (City College) with medals and certificates of merit for outstanding performance in riflery. The stamped signature of Jerold C. Hoffberger, past president of the National Brewing Company, former owner of the Baltimore Orioles, and international philanthropist, appears on this certificate. (Clement D. Erhardt Jr., photographer)

Shown here is a certificate awarded to the same James Jackson by the Baltimore Police Boys Clubs and the National Brewing Company for excellence in basketball.

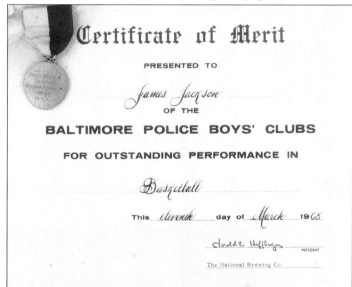

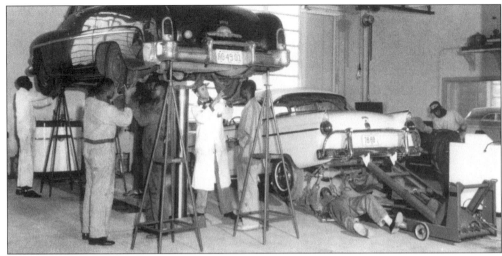

Carver Vocational Technical School began in 1925. Originally created to provide formal training for boys, the school eventually widened its enrollment to include women. At Carver, students learned trades in carpentry, tailoring, auto mechanics, plumbing, engineering, as well as cosmetology. In this picture, beneath the car on the hydraulic jack raised to eye level, students gain hands-on experience in how to properly fit tires. The rear plate on the car is registered in Maryland and dated 1956. At the far right of the photograph, another man appears to be learning how to rotate a tire. (In real life, when has the shop floor of a garage ever looked so clean?) Carver auto mechanics graduates were well sought after for hire by companies all over Baltimore.

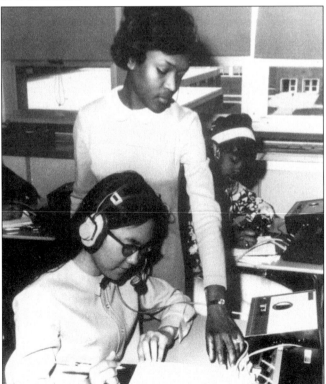

Western High School, originally open to white girls only, has an illustrious history of churning out high achievers. By the 1950s, lighter-skinned African-American girls were accepted into the school. Girls with darker complexions were admitted if they exhibited exceptional abilities. In this c. 1969 picture, the teacher, Ms. Evelyn McClarry, instructs her students in the use of (then) state-of-the-art-transistorized equipment in her German language laboratory class. Ms. McClarry later went on to become the first multicultural coordinator at Roland Park Country School for Girls.

The Cortez W. Peters Business School was co-founded by Cortez Peters and Walter Thomas Dixon in 1935. Scores of African Americans attended the school at its locations at 2000 Druid Hill Avenue, 1200 Pennsylvania Avenue, and 529 Gold Street for training as clerical and professional workers. The school was also an accredited international business school, and according to this issue of the school's bulletin, it was considered "one of Americas finest privately owned Negro business schools." One of three national branches, the Baltimore school co-existed with a Washington, D.C. site, at 1308 U. Street (founded first), and a Chicago branch, at 444 E. 47th Street. Some of the courses offered included shorthand, business English, accounting, commercial law, insurance, journalism, office practice, business administration, and civil service courses.

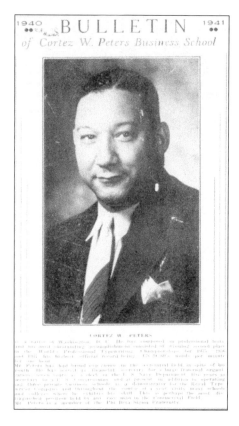

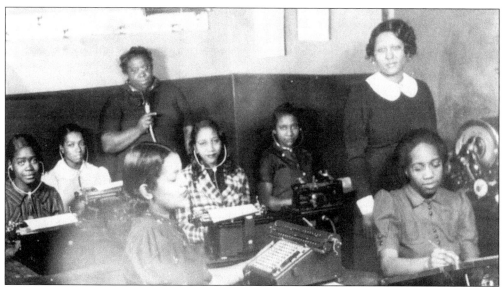

Longtime registrar of the Cortez W. Peters Business School, Evelyn Wilkey, is shown here at the back of her class. Ms. Wilkey was a known disciplinarian who adhered to promptness and diligent work.

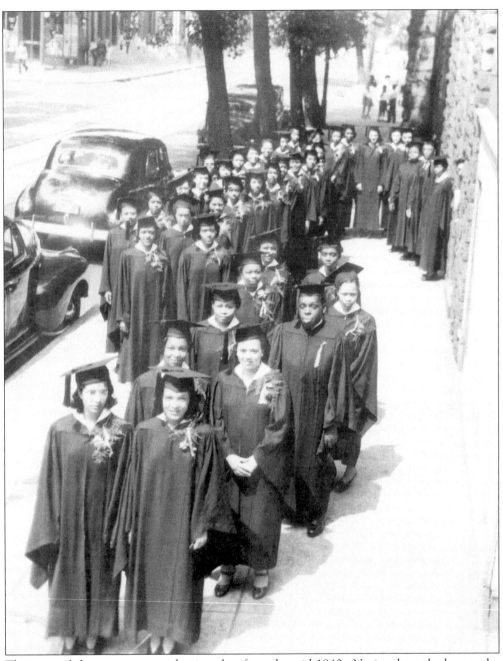

This unusual shot captures a graduating class from the mid-1940s. Notice the onlookers at the rear of the column. The picture is dated by the vehicles parked on the street.

This ornate program commemorates the celebration of the tenth anniversary of the Cortez W. Peters Business School after its inception in 1935. The gala event was held at Enon Baptist Church, at Schroeder Street and Edmondson Avenue. Greetings were given by class graduates from 1938-1946. Note the emblem of the National Council of Business Schools, which is highlighted as the centerpiece of the program cover. This program is a fine example of the high quality of work produced by the black printing house, Clarke Press, located at 2120 Druid Hill Avenue, Baltimore.

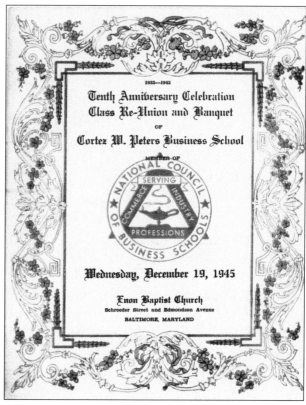

In May 1939, Miss Inez Mason was crowned "Miss Coppin," the Homecoming Festival Queen. Here, she is pictured in her glory with two train bearers (seen left holding the hem of her gown), and two flower girls alongside. Coppin School was founded in 1900 and dedicated to the purpose of training elementary school teachers. In 1926, the school was renamed Fannie Jackson Coppin Normal School and taught extensive programs in education and social work. Fannie M. Jackson was a former slave and one of the first black women in the United States to graduate with a college degree. Her life's work was the education of African-American youth. In 1938, the school was renamed Coppin Teachers College with a four-year curriculum and authority to grant the Bachelor of Science degree. Located on North Avenue, the school is now called Coppin State College. In 1988, the college became part of the University of Maryland System.

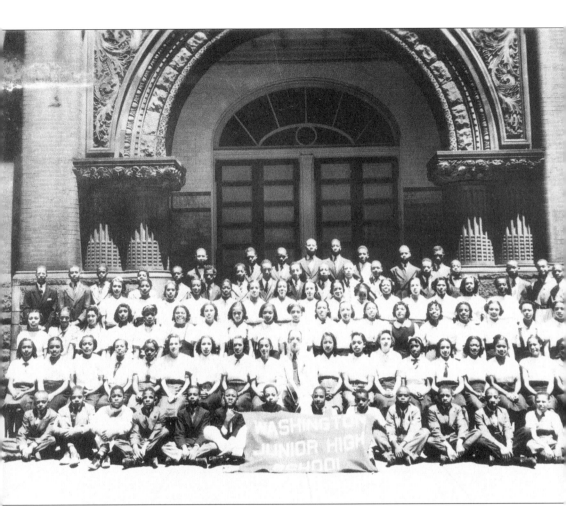

Pictured here are the 1939 graduates of Washington Junior High School. The majority of these students went on to Douglass High School and would have graduated in the class of 1942. Some of them who went on to be prominent in their chosen fields include Samuel Owings, Paul Branch, John Poag, Ruth McGuinn, Clarence Blount, Melba Rawlings, Ida Woodford, and Vernon Sheffey. As of this writing, Clarence Blount serves as a member of the Maryland State Senate. The school, which is still operating today on McCulloh Street as Booker T. Washington Middle School, is known, among other things, for its excellent jazz band. (Paul Henderson, photographer)

This dashing figure of a man is Charles M. Woodford. He graduated from Howard University in 1915. A veteran of WW I, Charles relocated to Baltimore in 1920, and went on to devote three decades of his life to the teaching profession. The bulk of Woodford's tenure as a teacher was completed at Douglass High School, while in the 1940s, he taught at Dunbar High School. Also pictured is a letter from the principal of the Colored High School (renamed Frederick Douglass High School in 1923) to Woodford, offering him a teaching position in manual training for an annual salary of $1,500. The principal, Mason A. Hawkins, who is credited with being the longest-serving principal in the history of the school, writes: "You will please report for duty Sept. 13, 1920." (photographed by G.G. Donaldson, a black photographer from Washington, D.C.)

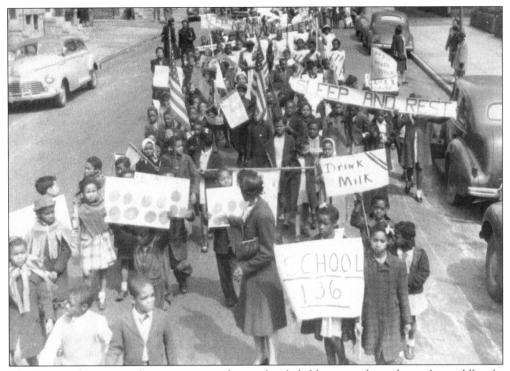

This picture shows something not seen today—school children marching down the middle of a street on parade. These children, carrying banners, hand-made signs, and posters, are taking part in a Negro Health Week parade. School Number 136, represented here, was located on 24th and Howard Streets. Bystanders looking on received good common sense advice on health and wellness: keep neat and clean, take a bath, eat apples, eat lots of vegetables, drink milk, and get lots of fresh air and sleep. There are several patriots in the parade carrying the American flag.

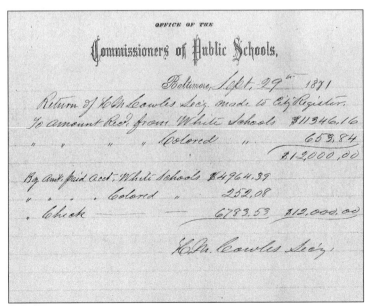

This c. 1871 accounting redord, on stationery of the Commissioners of Public Schools, shows how much money was spent on white and colored schools. Note the disparity between the allocation of funds, with the black schools receiving only 2% of the annual budget.

Do you remember playing "tunnel ball," like these children in Ms. Maddox's physical education class? In more carefree days, this game was guaranteed to enable even the weakest athlete to scurry to the front of the team line and pass the ball between each member's legs. The first team to wind up with the leader back at the front of the line would rush to sit on the asphalt and be crowned "king."

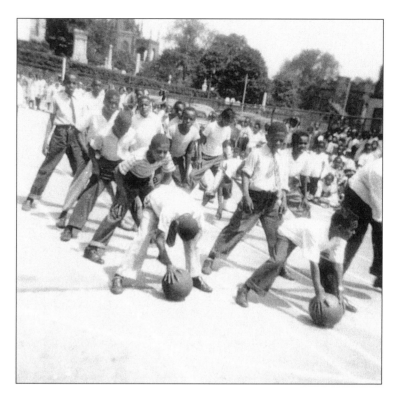

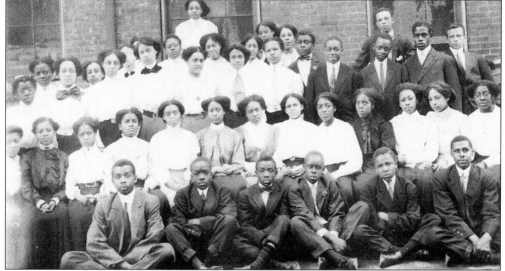

Leonard Ulysees "Duck" Gibson (third row, second from right), who went on to be a longtime athletics director at Frederick Douglass High School, is seen in this 1910 photograph of the 42 students in the graduating class of Colored High School (located at Mount and Saratoga Streets). This was one year after Mason A. Hawkins (who wrote his Ph.D. thesis on the development of what, in 1923, became Frederick Douglass High School) took over the position of principal at the school. Hawkins was the longest-serving principal of the Colored High School.

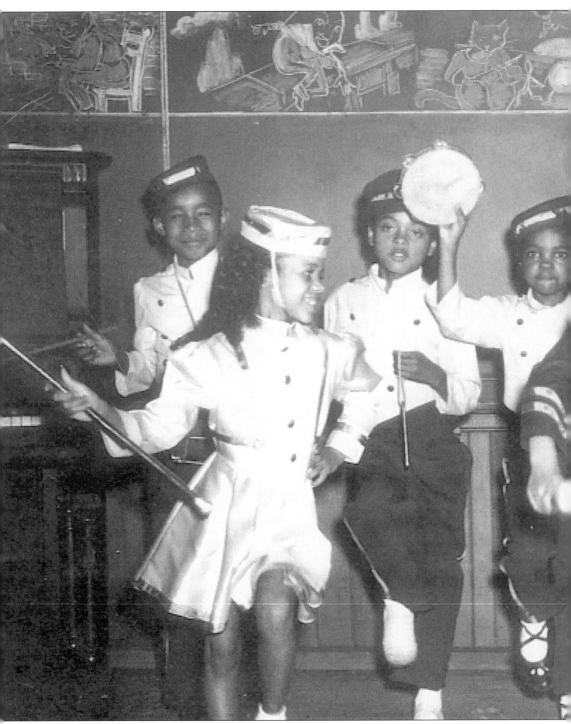

On July 15, 1949, these animated third graders of the Marching Rhythm Band performed a scene in A *Spring Fantasy*, a citywide creative project held at school number 135. Photographed are drum majorettes, drummers, a triangle player, cymbal player, and a tambourine player. The chalk drawings on the blackboard depict scenes from children's all-time favorite rhymes and

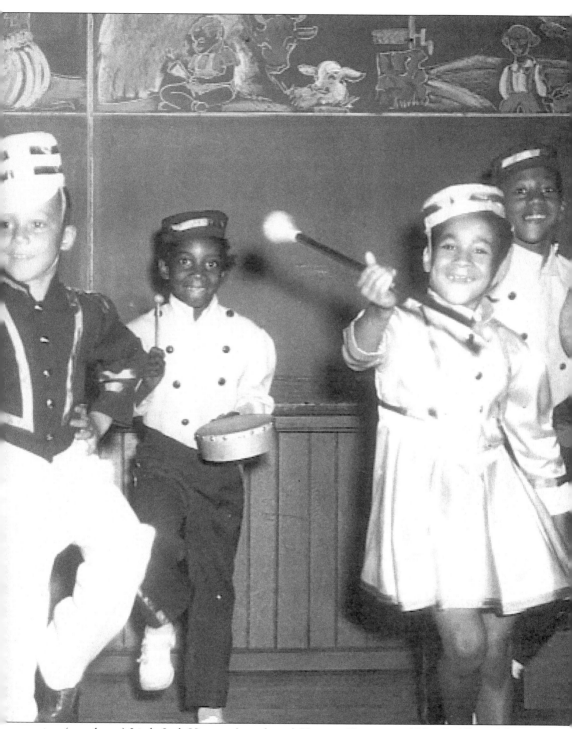

stories: (panel one) Little Jack Horner, (panel two) Humpty Dumpty and Hey Diddle Diddle, and (panel three) Jack and Jill. Jack Engeman Studio, photographer; 701 St. Paul Street, Baltimore, MD.

THE BOARD OF DIRECTORS AND SUPERINTENDENT

OF THE

MARYLAND SCHOOL FOR COLORED BLIND AND DEAF

CORDIALLY INVITE YOU TO ATTEND THE

ANNUAL EXHIBITION AT THE SCHOOL

649 WEST SARATOGA STREET, BALTIMORE, MD.

ON THURSDAY, JUNE THE SEVENTH

NINETEEN HUNDRED AND SIX

FROM TWO TO NINE P. M.

(OVER.)

The Department for Colored Blind and Deaf, of the Maryland School for the Blind, operated from 1872 to 1955. In 1906, the Maryland School for the Colored Blind and Deaf hosted an exhibition to show firsthand the work done at the school. Visitors could observe students' literary works; manual training in such areas as chair caning, mattress making, and shoe making; domestic skills including cooking, serving at the table, cleaning, and sewing; and physical education, including acrobatics exercises with dumb-bells. Robert W. Coleman of Coleman Printers was a student at the school. In 1955, deaf students from the Department for Colored Blind and Deaf transferred to the Maryland State School for the Deaf.

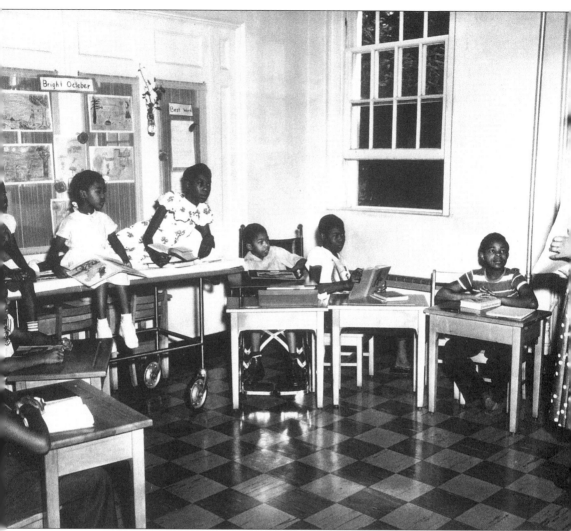

These handicapped children are enthralled by the story their teacher shares with them during a reading and comprehension class. Since this photograph was taken in the 1950s, technological strides have improved education for physically and mentally challenged children. Note each student's book has a different title from that of his or her neighbor. (Jack Engeman Studio, photographer; 701 St. Paul Street, Baltimore, MD.)

In 1926, the senior graduating class at Morgan College edited the first yearbook of the school, entitled *Em See*. In 1867, five men created a charter to begin a seminary for young men called Centenary Biblical Institute. The school grew by leaps and bounds. Then, in 1890, a generous donation from board member Rev. Dr. Lyttleton F. Morgan enabled the school to offer secular collegiate training. The school charter was rewritten and the school was renamed Morgan College. Today, the school is known as Morgan State University, and it has produced scores of prominent graduates, including Earl Graves, founder of Black Enterprise Magazine; Clarence "Big House" Gaines, a famous Winston-Salem State University basketball coach; and former Congressman Kwesi Mfume, who presently heads the NAACP, just to name a few.

# Four
# CHURCHES AND LANDMARKS

The Reverend Dr. George L. Imes (1886–1957), who was a tireless worker on behalf of Baltimore's African-American youth, penned this version of the Lord's Prayer. The aim of Reverend Imes' "modernization" was to help his charges remember the prayer more easily, without removing the essence of beauty, dignity, or reverence for the original. This version of the Lord's Prayer was sold throughout the Goodwill organization. A close colleague of G.W. Carver, Booker T. Washington, Robert Russa Moton, and Mordecai Johnson at Tuskegee Institute, Dr. Imes wrote frequently to the Baltimore *Sun* concerning the plight of Negroes. He also hosted *The Negro Hour* on Baltimore radio station WFBR-AM during the 1940s. The artist's design decorating the prayer is loaded with biblical symbolism: the Rose of Sharon, the lily, the bright and morning star, the vine, and the branches.

The Black Church has played a significant role in the lives of African Americans throughout history, serving not only as a means to bring them to God, but provide organization and structure to the struggles against slavery, segregation, and discrimination. Church records, if and when they are kept, provide an excellent resource for following the life history of the congregation, through such documents as baptism certificates, marriage licenses, and obituaries. This certificate declares that on the sixth of November 1949, Patricia Ann Jackson was presented to the Lord in a Dedication service at Union Temple Baptist Church. The ceremony was performed by the Reverend Robert Lewis.

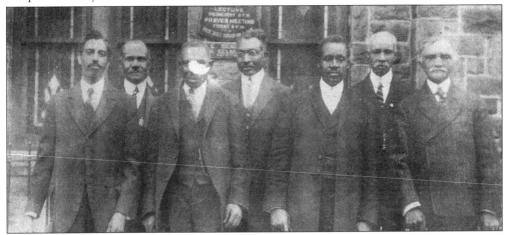

Macedonia Baptist Church was founded in 1874. The year 1999 marks the 125th anniversary of the church. This photograph is of the Deacon Board standing in front of 1617 W. Saratoga Street, where the church stood from 1896 to 1925. On May 3, 1925, the church relocated to its present site at 718 W. Lafayette Avenue. Represented in this photograph, from left to right, are as follows: Deacon George F. Holmes, Deacon I.P. Patterson, Deacon Everette Seger, Deacon Charles B. Cook, the Reverend Daniel G. Mack, D.D. (pastor of Macedonia from 1903 to 1943), Deacon Anderson Simmons, and Deacon Sandy Moody.

Pictured here is a magnificent image of the Leadenhall Baptist Church on South Baltimore's Federal Hill. It was built in 1873, by the Black Baptist Sharp-Leadenhall Area Union Association. Today, the building looks just as proud and commanding as in this photograph. (Arthur L. MacBeth, photographer; MacBeth Studio, 1030 Pennsylvania Avenue, Baltimore, MD.)

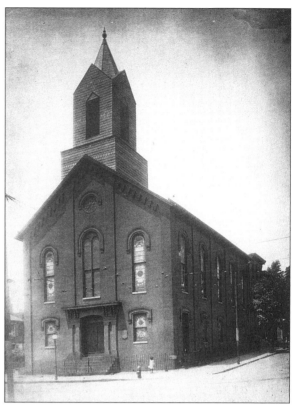

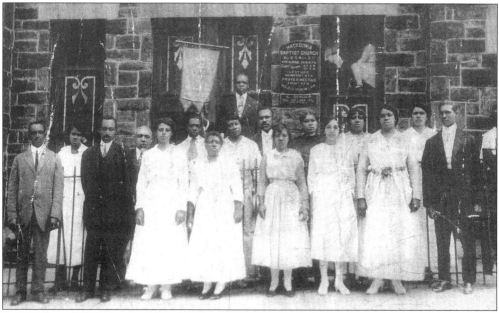

An unidentified ministry of Macedonia Baptist Church stands at 1617 W. Saratoga Street. Only a few names are known. From left to right, they are as follows: (front row) Maggie Lakeman, third person; Etta Cawthorne, fourth person; and Wilhemenia Vincent, seventh person; (back row) Fannie Gresham Gilles, on the end.

Taken in 1961, this picture is of the author's great aunt, Florence Burroughs, and a friend on their way to church. As was proper for ladies of the time, they wore hats, gloves, polished shoes, and to complement the whole outfit, carried matching pocketbooks.

Here is a 1920s photograph of a solemn-looking couple in wedding attire. The groom is dressed in tails, wearing what appear to be two pens in his coat pocket, and is seated on the arm of an ornately trimmed chair. Note that his hands are gloved. The bride is in traditional pose for the time, standing alongside her husband to show off this simple, yet unmistakable, all white dress and veil. Around her neck appears to be a watch, dangling from a long chain. On the reverse of this picture is the inscription, "To Mrs. Lillie Brown."

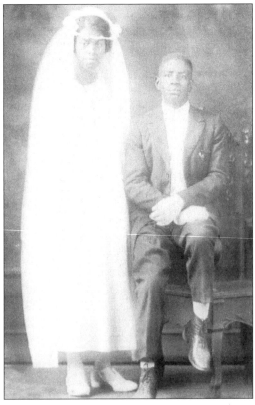

On the 27th of July 1947, Charles L. Robinson and Carrie Smith were wed by the Reverend George Smith of the Pennsylvania A.M.E. Zion Church. At the time, Charles was a boiler cleaner at Baltimore Copper Smelting & Rolling Co., and Carrie worked as a cook. Both had been previously widowed. The seal stamped on the bottom left-hand corner is from the Court of Common Pleas.

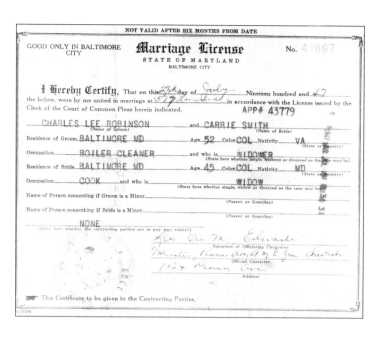

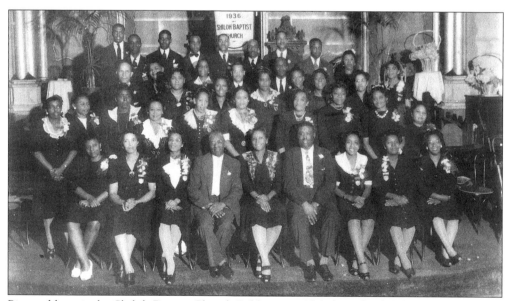

Pictured here is the Shiloh Baptist Church Publication Club (1936). Shiloh, then pastored by the Reverend Timothy Boddie (front row, sixth from left), was located at 821 West Lanvale Street. In 1990, Shiloh (now New Shiloh Baptist Church) moved to a newly constructed facility at the corner of Monroe and Clifton Streets. Also pictured here are Charles Woodford (third row, first from the left), Margaret McCoy (third row, third from left), and Leonard Coleman (last row, in front of chair). (Paul Henderson, photographer, 1943.)

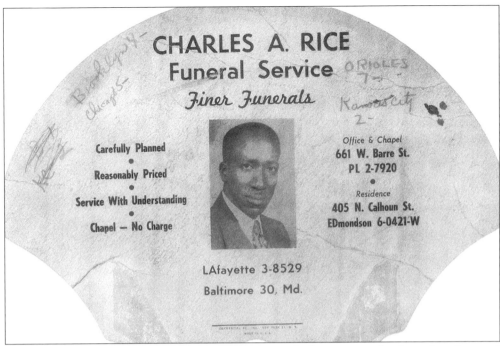

Today, as in earlier times, fans are used as a form of advertisement by funeral parlors and churches. In 1943, the Joseph A. Lively Funeral Parlor was located at the 661 W. Barre Street. This same address was later occupied by the Charles A. Rice Funeral Service, whose 1950s style fan is pictured here. Note that one holder of the fan used it to record baseball scores.

The concept of "going home to meet one's Maker" has always been taken very seriously by the African-American community. Hence, some African Americans have traditionally favored elaborate funerals or "going home" services, with magnificent flower arrangements and uplifting church musical arrangements. This woman is the grandmother of the Gilbert Allen family in Baltimore. Notice the ribbon entwined in the bouquet above her head, which says "Mother," and the expensive lace that overhangs her coffin. Here, the photographer E.G. Lane has captured an unusual shot with a close-up of the deceased in her casket. Often, funeral images were taken as wide shots showing the casket lengthwise surrounded by beautiful flowers.

```
                    THE YOUNG WOMEN'S CHRISTIAN ASSOCIATION
                           FRANKLIN STREET AND PARK AVENUE
                                  BALTIMORE, MD.
OFFICERS                          TELEPHONE, VERNON 1460              BRANCHES

MRS. WILLIAM G. BAKER, JR., PRESIDENT                          CENTRAL BUILDING, 128 W. FRANKLIN ST.
MRS. EDWARD GUEST GIBSON  } VICE-                              EAST BALTIMORE BRANCH, 28 SOUTH BROADWAY
MRS. GEORGE A. SOLTER     } PRESIDENTS   MISS MARY FRANCES DAY INTERNATIONAL INSTITUTE, 28 SOUTH BROADWAY
MISS JANE J. COOK, SECRETARY              GENERAL SECRETARY    DRUID HILL AVE. BRANCH, 1200 DRUID HILL AVENUE
MRS. EDWARD L. ROBINSON, TREASURER                                     (COLORED)
MRS. ROBERT M. LEWIS                                           WATERS' SUMMER HOME, REHOBOTH, DELAWARE
         ASSISTANT TO TREASURER                                GIRLS' RECREATION GROUNDS, WALBROOK
                                                                   (LOANED BY CITY PARK BOARD)
```

Druid Hill Avenue Branch

My dear *Mr & Mrs Bishop*

    As citizens of Baltimore we feel sure that you are interested in the community. The Young Women's Christian Association offers development through Physical, Mental, Moral, and Spiritual training for women and girls.

    In order to continue our work we must have the interest of the citizens and also a larger membership.

    We would like to extend to you an invitation to attend our Mass Meeting, Sunday May 21st, at Union Baptist Church, Druid Hill Avenue, at 3 P.M.

Speakers:

Rev. Green of First Baptist Church.
Mr. Morris, Secretary of Y.M.C.A.
Bishop Brook from Liberia, West Africa.
Mrs. Croll, Membership Secretary Y.W.C.A.
Rev. Walker, Madison St. Presbyterian Church.

Bring a friend with you.

                Yours sincerely.

                    A. E. Hitchens,
                    Chairman.

During the time this letter was written to Mr. and Mrs. Bishop, the Colored Young Women's Christian Association was located at 1200 Druid Hill Avenue. The Bernard L. Matthews Senior Residence stands on this site today. The following is an excerpt from the 1926 *Em See* (the Morgan College Yearbook) taken from the YWCA Club "Y" Song:

        If she's smiling all the while, she belongs to the "Y"
        If she's true, sincere with you, she belongs to the "Y"
        If for the right she'll always stand, if she'll lend a helping hand
        Her true personality is a reality, she belongs to the "Y."

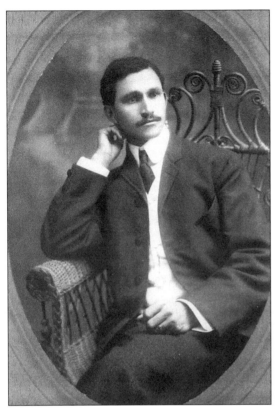

Here is a photograph of William F. DeBardeleben, who in 1913 was the General Secretary of the Baltimore Colored YMCA. Degreed from Lincoln University (B.A.) and the University of Pennsylvania (M.A.), DeBardeleben worked closely with the different branches of the "Y" across the country, providing community assistance in areas such as religious, recreation, and political activities. In the 1930s, he was a professor of biology at Miner Teachers College in Washington, D.C.

A new YMCA was eventually built and is now located at 1621 Druid Hill Avenue (previously 1619 Druid Hill Avenue). The sign in the window of this picture reads, "Colored Young Men's Christian Association, Special Men's Meeting, Sunday 4:30 pm, Rev. A.B. Callis, All Men Invited, Bring a friend, Good singing."

This commuter, Mrs. Olivia P. Dixon, is returning from a social work conference in Chicago by railroad. She is pictured in front of the station on her way home. Notice the arched entrance to the station.

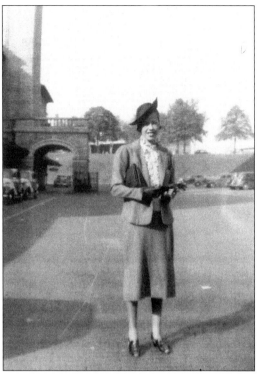

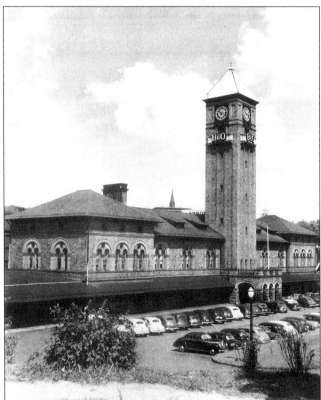

The B. & O. Tower, shown here, has been altered over the years. At the time of this photograph, this site was a full-fledged railroad center called Mt. Royal Station. The building is presently occupied by the Maryland Institute College of Art. Once a year, an art show is held at the old B. & O. building on the eve of Baltimore's Artscape Festival, which takes place during the summer. A stage is erected in front of the balcony for performing acts. The venue space is shaped like an amphitheater and is ideal for concerts. In recent times, performers Patti La Belle, Peabo Bryson, and Aretha Franklin have showcased their extensive talents here.

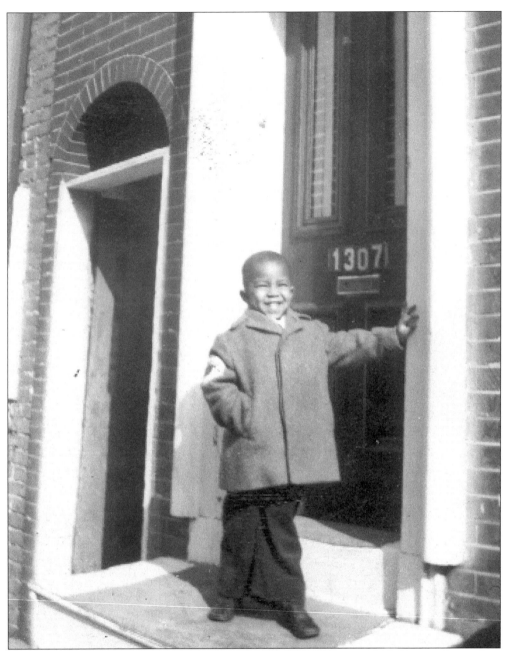

This picture shows the author's uncle, Martin Jackson, at age five in 1946. He is in front of our family home at 1307 N. Stockton Street, which had four entrances: front, back, and two side doors. One side door led into the kitchen and the other into the hallway. Our house had eight rooms and a cellar. One of two three-storied houses in the block, number 1307 was the only semi-detached building on the street with an airway (see left door, below stair level in picture). The street at this time was cobble stoned, and the wooden steps in the photograph were later replaced with marble steps. According to the previous white owners of our house, Stockton Street used to be called Patterson Street. "Betsy the Duck" and friends (including chickens) lived at the rear of the house (see page 118).

# Five
# BUSINESS AND LABOR

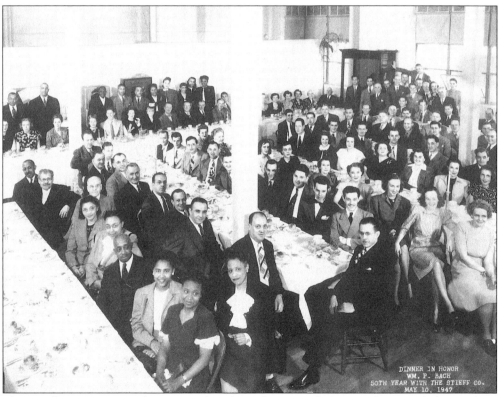

The Stieff Company in Baltimore produced a wide range of silver products, including cutlery, plates, and ornaments. This photograph shows company employees at a 1947 affair, honoring a 50-year employee of the company. Note that the black employees are seated at a separate table and line the back wall in the picture, separate from their white counterparts. The Stieff Company closed down its operations in 1998. (Henry Cronhardt & Son, photographers; this company was a popular commercial photography firm that captured many scenes around Baltimore starting in 1888.)

The Chesapeake Marine Railway Co. (left-hand side of photograph) was a black-owned company located in historic Fells Point. Co-founded in 1866 by Isaac Myers, John W. Locks, and other partners as the Chesapeake Marine Railway and Dry Dock Company, it was located at the site of Kennard's Wharf at the end of Philpot Street, which had been a receiving dock for shipments of slaves. Frederick Douglass himself first entered Baltimore at this site in the 1820s. The Chesapeake Marine Railway and Dry Dock Company served as the center of the city's shipbuilding industry employing both black and white labor. In 1884, the company ceased operations. Isaac Myers, a known activist in educational, political, religious, and labor union circles, was a strong advocate for improving the quality of life for African Americans. A member of Bethel A.M.E. Church, Myers served as the superintendent of the Sunday school. He also helped to form the African Methodist School Union. John W. Locks also attended Bethel A.M.E. Church. Locks worked as a caulker and eventually became a supervisor in the shipyards. It is reported that in 1884, Locks was the largest stockholder in the Chesapeake Marine Railway and Dry Dock Company. Locks was also a skilled hack and funeral operator.

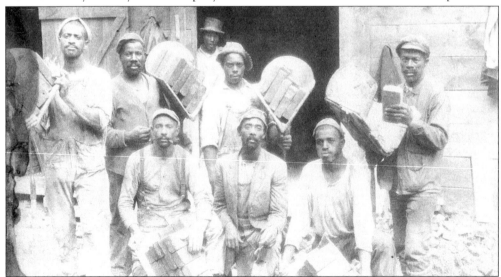

This picture, taken in the 1920s, captures hod carriers dressed in their working garb and holding their hods. The personality of each man is expressed through his cap. In the 1940s, the International Hod Carriers and Building Laborers, Local Union Number 194, had an office located on 317 N. Paca Street.

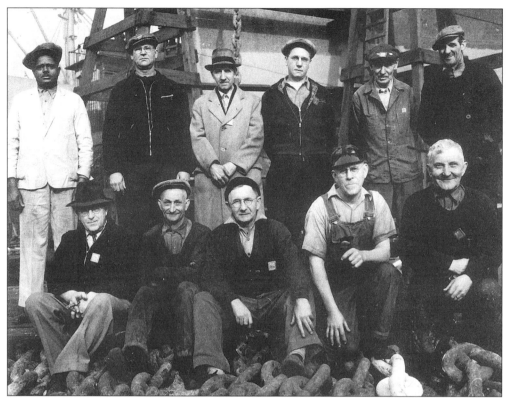

At one time, Bethlehem Steel Shipyard was the largest employer in the state of Maryland. Longshoremen, like those pictured here, were typically part of unionized labor. Many blacks, who worked as longshoremen, were able to purchase homes and property, as well as put their children through college, because this occupation paid excellent wages. Sometimes generations of families worked at the yards, as a son would eventually replace a retiring father. This image was taken in the 1940s.

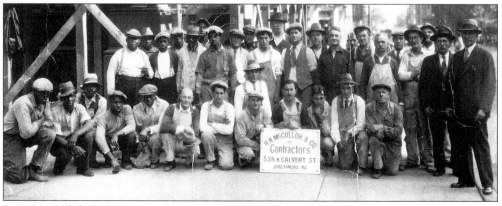

R.N. McCulloh & Co. was a white owned and operated stonemason contractor company. This company photograph shows 35 employees, one third of whom were African American.

One of the leading black printing presses in the first half of this century was established and operated by Jesse B. Clarke, under the name of Clarke Press. Located at 2120 Druid Hill Avenue, Clarke Press specialized in school and college publications. Its advertising slogan was confident and humorous: "For Quality Printing Jes—see Clarke." This 1949 calendar, put out by Clarke, also served as a mini-reference for editing text. The reverse of this calendar doubled as an ink blotter. Clarke Press was responsible for printing materials for the Cortez W. Peters Business School (see 1945 Tenth Anniversary celebration program, page 57). Jesse Clarke Sr. died in 1949, and his son, Jesse B. Clarke Jr., operated the business until his death in 1959. Joshua F.L.G. Duvall, G.B. Maddox, Ernest Hoban, Watkins & Wells, Beacon Press, and C.M. Dorsey are names of other black presses that operated in the same time period.

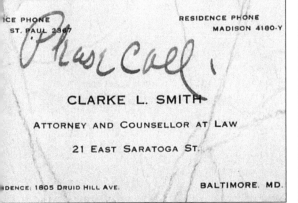

*Left:* Clarke L. Smith was a well-known lawyer whose specialty was handling real estate matters. In November 1914, he was one of 68 successful candidates to pass the Maryland Bar Examination from a pool of 160 applicants. A member of the executive committee of the NAACP, he also pledged membership in the now defunct Thomas W. Stringer Lodge of the Knights of Pythias, and belonged to St. James Episcopal Church in West Baltimore. Clarke was also a member of the executive committee of the Monumental Tennis Club in 1924, which hosted the American Tennis Association in Baltimore for a week's activities. The short telephone numbers and absence of zip codes in the addresses date Smith's practice. In the 1920s, Clarke managed the Banneker Building Company that leased office space to black professionals. *Right:* The John A. Bishop & Son, Co. was a black funeral parlor located at 1107 Druid Hill Avenue. The company, which later moved to 1216 McCulloh Street, was purported to have housed equipment and facilities in the basement for embalming, such as benches, embalming chemicals, and carpentry tools. In the late 1800s, John Bishop, also a skilled cabinet maker, customized coffins for his clientele.

This exceptional print was developed from a turn-of-the-century glass negative. These three sporty gentlemen are posing in front of National Enameling & Stamping Co., successors to Matthai-Ingram Co. in South Baltimore. This Baltimore company was a national leader in the production of household appliances such as covered buckets, coffee pots, and wash boilers. Matthai-Ingram Co. began its business in 1869. In 1895, this firm employed 100 workers in a floor space covering eight acres. Each man in this picture is wearing a different style hat, while two are wearing suspenders, two are wearing ties, and one wears a collarless shirt. The right window is festooned in ornate ironwork, and the window frame reveals bevelled leaf and diagonal designs.

Hendin's was a name synonymous with affluence. It was the kind of store where young girls dreamed of being able to dress like the glamorously clad mannequins in the windows. Hendin's profited from its enduring reputation for carrying well-tailored, quality, high fashion. Originally located on Pennsylvania Avenue, the store later moved to Mondawmin Mall. This picture shows Mayor Thomas D'Alesandro Jr., standing beside Walter T. Dixon at a ribbon cutting ceremony to mark the official opening of the new Lafayette Market opposite Hendin's on Pennsylvania Avenue (front row, fourth and fifth from left).

Former City Councilman Henry G. Parks Jr. headed one of the nation's most successful businesses, H.G. Parks Inc. Later known as Parks' Sausage, this company employed many African Americans and, though struggling, is still operating today. The back of this "Link Sausage" carton alerts consumers that the sausage is made from traditional family recipes and still bears Mr. Parks' signature. Henry Parks is shown in this photograph of the Frontiers Club, a social club for men (second row, sixth from left). Also shown are Marse S. Calloway (third row, third from right), former City Councilman Walter T. Dixon (first row, fifth from right), Ralph Reckling (first row, fourth from right), and Furman Templeton (third row, first from left) The group is posing in front of the York Hotel, formerly located at Dolphin Street and Madison Avenue. Advertised as the best colored hotel in the south, the York had 13 baths and every room had water.

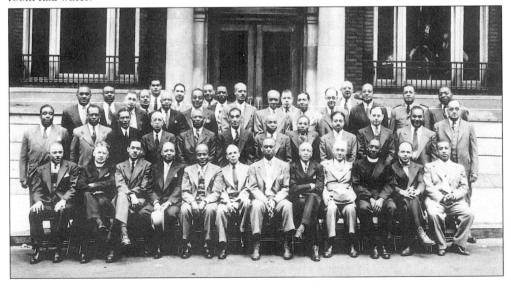

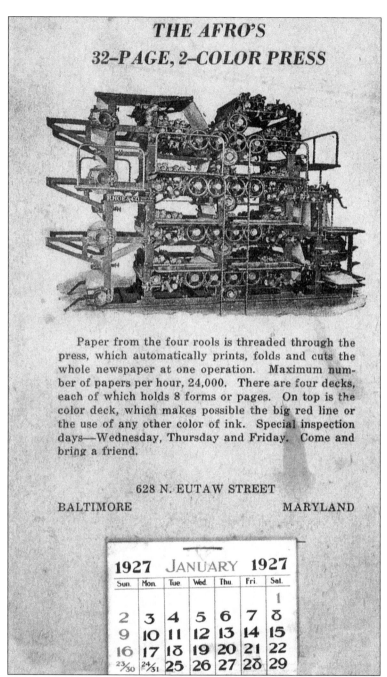

The *Afro-American* newspaper was, "and still is," an information resource in many black homes. The paper boasted of a readership of close to a quarter of a million people in 1945. During its prime, the *Afro* put out a national edition as well as local editions in New Jersey, Philadelphia, Richmond, Virginia, Washington, D.C., and Baltimore. However, as with other black enterprises that survived WW II, modern technology and increased integration inevitably led to downsizing. Thus, the *Afro* closed two-thirds of its offices and today is published only in Baltimore and Washington, D.C.

This glowing reference letter was written for the author's great aunt, Florence Burroughs, who worked for many years as a domestic for the Scholz family in Roland Park, Baltimore. This letter reminds us of the importance of finding dignity in a job well done and of valuing integrity over short-term financial gain. The letter reads as follows:

"August 25, 1955

To Whom It May Concern:

Mrs. Florence Jackson Burroughs was in my employ from September 1948 until February 1955, and it is a pleasure to be able to recommend her.

I found her intelligent, pleasant, humorous, resourceful, and levelheaded in emergencies. She did general housekeeping and cooking, but had extraordinary ability to understand and care for children. On many occasions my husband and I left her with our four children while we took vacations.

We found her to be excellent, and imaginative. Her character is beyond reproach. She is completely reliable and honest.

She left us voluntarily in order to be married.

Pearl Huffman Scholz, MD

Telephone: Tuxedo-9-7679, Baltimore"

Baltimore is thought to be the last bastion of port cities across America in which the "Arabber" (pronounced "Ay-rabber") still survives. In their heyday, Arabbers took their horses and wagons to the wharves to buy fresh fruits and vegetables to sell in Baltimore's inner city districts. Famed for their distinctive songs announcing their wares, Arabbers have become a part of Baltimore legend. This tri-colored (yellow, red, and green) wagon holds fruit, vegetables, peanuts, and other items and is horse drawn. Generations of families have continued the tradition of arabbing, which has been handed down from generation to generation. (Dennis Milecki, photographer; Baltimore, MD.)

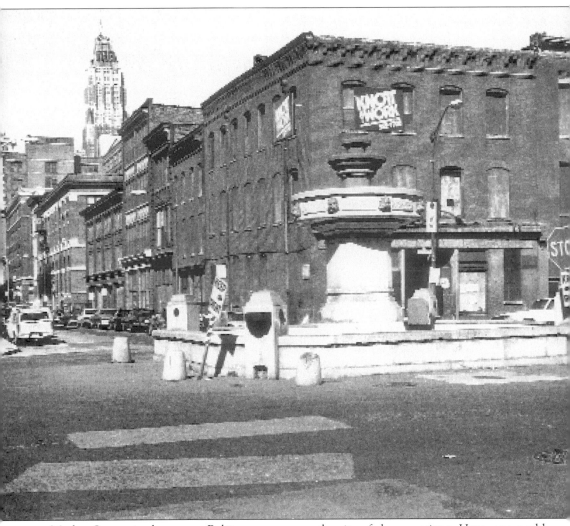

Market Square in downtown Baltimore was once the site of slave auctions. Here, one could purchase, sell, or trade human inventory for work as a domestic or on the plantation. The fountain is still centered in the marketplace cul de sac in front of the buildings shown in this picture. This photograph showing the "Knott At Work" remodeling advertisement sign was taken before revitalization of the Brokerage in Baltimore, which began in the mid-1980s. The boarded up buildings have been remodeled and repaired and are part of a multi-use complex, opposite the Port Discovery Children's Museum.

The Commonwealth Bank, at Howard and Madison Streets, was a white owned and operated institution where several wealthy and prominent blacks held their money. This check was made out to attorney William L. Fitzgerald for $5 by John A. Bishop, who was a successful funeral parlor operator in 1918. Forty years later, Fitzgerald was presented with a resolution from the City Council of Baltimore formally recognizing his longtime achievements and contributions to city commerce, and congratulating him on his 86th birthday. Highlights of his career included serving as Baltimore City Councilman from 1919 to 1923, being the first Negro to pass the written Bar examination in Maryland, and having a 58-year membership in the Bar in Baltimore City.

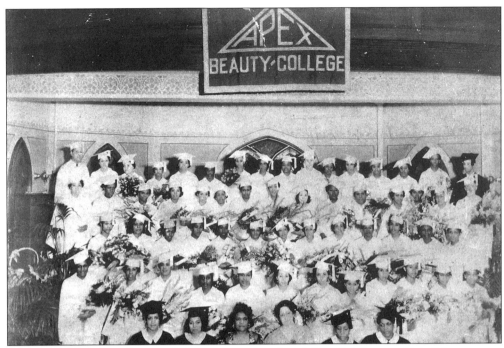

This rectangular Apex Pressing Oil canister was marketed "For Hairdressers Only." Its contents were used to prepare black hair for styling with a hot comb and would create a bright sheen on treated hair. The Apex beauty system and hair care products were established by Madame Sara Spencer Washington in 1913. By 1920, New Jersey was the headquarters of the Apex News and Hair Company, which produced a line of almost 75 hair care products and beauty aids. Apex remained a leader in hair care products for blacks until the 1960s. The Apex Beauty College, located at the corner of Pennsylvania Avenue and Walter Myers Court, trained students in the care of black hair. The school offered morning and evening classes and encouraged people to enroll year-round. In the late 1940s, the public was invited on certain days to try the salon for personal grooming. Styling for the ladies cost $1, as did haircuts for men. People who attended the salon put themselves at the mercy of the hairdresser. According to one former patron, "You could always tell when the young men in the community had been to Apex, because they always got scalped. Depending on the skill of the hairdresser, your hairstyle would vary greatly." In this photographic reminder of the institution, which helped to provide a living for many of its students, almost all the female graduates are holding bouquets while a lone male is shown graduating. (Paul Henderson, photographer.)

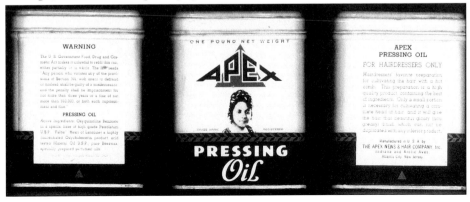

> **A GRAND MUSICAL**
> # ENTERTAINMENT
>
> Given by the Sunday School of
> **OAK ST. A. M. E. CH.**, Oak St., between 23rd and 24th
>
> **Thursday Eve. December 21, 1922**
>
> Mrs Collie Snowden, Chr.       Miss Julia Page
> Mr Harry Hiner, Supt.          REV. F. S. DENNIS, Pastor
>
> **Admission 10 Cents**  Refreshments on Sale
>
> ERNEST HOBAN, Printer.

Ernest Hoban was a man of many talents. By trade he was a printer as well as a teacher. In one edition of the *First Colored Directory of Baltimore*, Hoban advertised himself as "East Baltimore's most popular colored printer." This admission ticket to an evening of entertainment, hosted by the Oak Street A.M.E. Church on December 21, 1922, is a surviving example of Hoban's work. Note his business imprint at the bottom of the ticket. The Hoban printing office could be found at the rear of a confectionery store on 439 N. Caroline Street. Ernest also gave music lessons at his home, located at 21 S. Schroeder Street, in wind and string instruments, including the violin, cello, piano, mandolin, trombone, and cornet.

> ## DORSEY'S CITIES SERVICE STATION
> PENNSYLVANIA AVE. & MOSHER STREET
>
> BALTIMORE 3, MARYLAND
>
> **J. T. DORSEY**
> PROPRIETOR                          TEL. MADISON 3-9485

James T. Dorsey, an African-American entrepreneur and 33rd degree Prince Hall mason, owned and operated a gas station in Baltimore for 31 years. Since May 5, 1947, Dorsey's Cities Service Station has seen some famous, and not so famous, faces enter the station's yard. Stars who stopped by include Cab Calloway, Muhammed Ali, Nat King Cole, and Duke Ellington. One Christmas, Dorsey erected a makeshift stage at the front of his business, and Lionel Hampton and his band played Christmas carols to entertain patrons and passersby. While the musical show was excellent, congestion at the station was so great that customers could not fill up with gas. Dorsey convinced the band to parade on up the street and take the crowd with them. Dorsey, a shrewd businessman, maintained a high profit margin at the station, which so impressed petroleum giant Conoco that top executives were sent from the gas distributor's headquarters in Oklahoma to woo Dorsey into opening other branches throughout the region, but to no avail. Dorsey turned down Conoco and shortly thereafter, in 1978, retired from the business. Mr. Dorsey is a well-respected Baltimore citizen who has a Masonic lodge named after him in Germany.

1129 DRUID HILL AVENUE
BALTIMORE, MD.

NORTH CAROLINA MUTUAL
LIFE INSURANCE CO.
MD. BRANCH
1129 DRUID HILL AVE.,
BALTIMORE, MD.

Established in 1898 by John Merrick, the North Carolina Mutual Life Insurance Company became the largest Negro company in the world. W. Emmett Coleman, who was the district manager for Baltimore in the 1920s, boasted of the company's superior service given to clients. C.C. Spaulding's meteoric rise in the company, which was headquartered in Durham, North Carolina, reads like a novel. After joining North Carolina Mutual in 1921, he was elected President in 1933 and remained so until his death 29 years later. Currently, North Carolina Mutual Life Insurance Company still maintains offices throughout the United States, including Baltimore.

# Six
# Men of Action

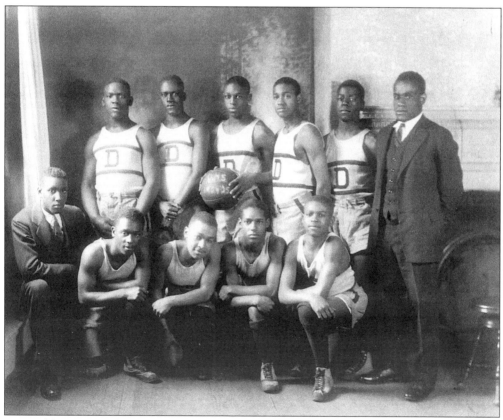

Pictured here is Coach Leonard U. "Duck" Gibson (far right), standing with the Douglass High School basketball team of 1924–1925. Of particular note is the athletes' attire: belted woolen shorts, knee-length socks, and pre-Converse sneakers. Sometimes athletes played on teams in different sports during the same season in order to fill the playing rosters.

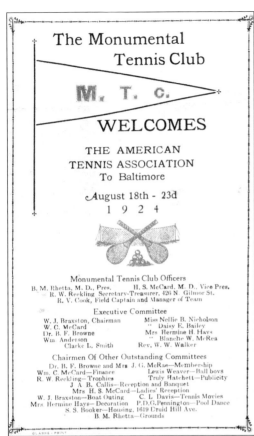

In 1924, the Monumental Tennis Club for blacks played host to the American Tennis Association for a week's activities at Druid Hill Park and elsewhere in Baltimore. Some of the activities included a pool dance, an excursion down the Chesapeake Bay, tennis movies at the Regent Theater, and to finish off the event, a reception and dance. It was not until 24 years later that the Druid Hill Park Tennis Courts would permit integration. This program was printed by Clarke Press.

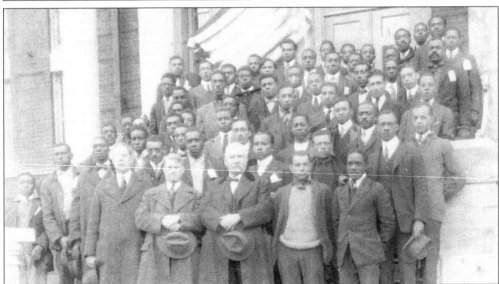

Standing in front of an unidentified Baltimore courthouse, these new inductees have just been drafted for service in WW I. We can see tags attached to the lapels of at least ten of the men. The gentleman standing in the last row, fourth from the left, is a relative of Charles and Sadie Brown of the Eastern Shore, Maryland.

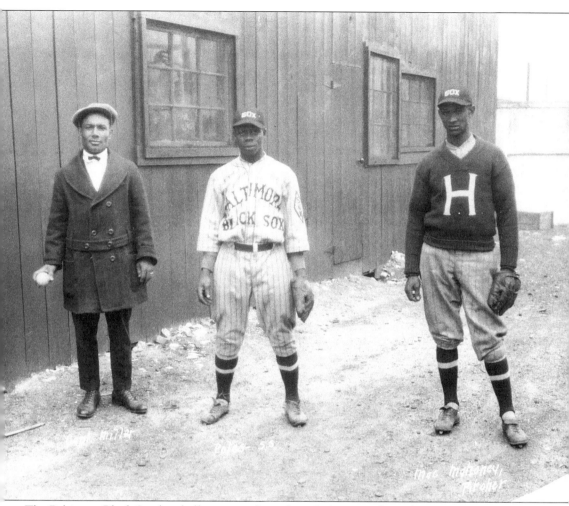

The Baltimore Black Sox baseball team was formed in 1916 as an independent team, but at that time, their standard of play was less than stellar. Here, we see three of the 1922 members of the team, from left to right, as follows: Miller, captain; Poles, short stop; and Mac Mahoney, pitcher. The Black Sox disbanded in 1934. Some famous players to come from Black Sox beginnings were Satchel Paige, Biz Mackey, and Leon Day. Paige and Day were both inducted into the Hall of Fame. Unfortunately, when there is talk of the Negro League's glory days, the Baltimore Elite Giants are more prominent in faded memory than the Baltimore Black Sox.

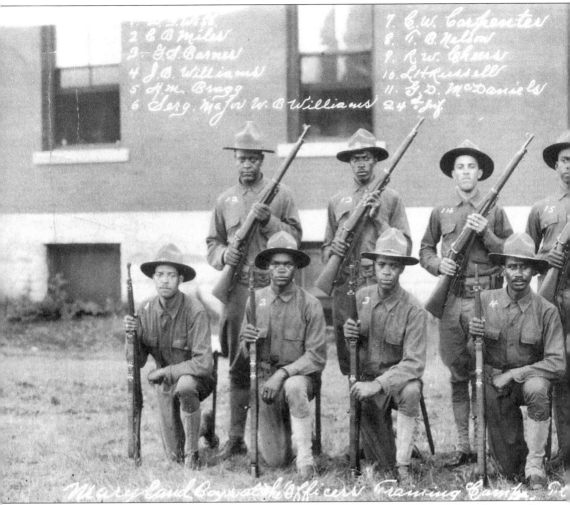

This is a partial image of Maryland soldiers in WW I uniforms at Officer Training Camp at Fort Des Moines, Iowa. Since this image is torn, only some of the men are identified. W.T. Webb (#1 on front row, first from the left) graduated from Morgan College in 1926 and was a member of Kappa Alpha Psi. In his civilian life, he was the supervisor of physical education in the Public Schools of Baltimore. Gough D. McDaniels (#11, not shown in this photograph) was a student at the Colored High School in Baltimore. After graduating from Brown University, he returned to his old high school where he was a longtime history teacher. McDaniels was also an avid sportsman and belonged to the Monumental Tennis Society. He was the president of the Colored School Alumni and the Kee-Mar Dramatic Club.

Sergeant James W. Murray was honorably discharged from the United States Army, Company F, 372nd Infantry on January 7, 1946. Stationed at Hawaii and Fort Meade, Sergeant Murray received four decorations for service. Born in 1910, Murray hailed from 1412 Myrtle Avenue in West Baltimore.

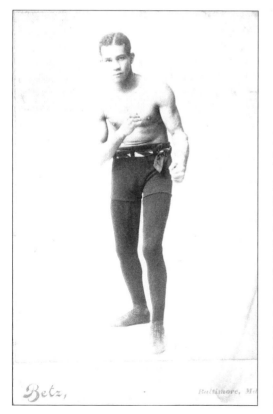

Pictured here is boxer Harry Lyons, who was captured in this rare shot in the late 1800s. This picture came out of the personal photography collection of another boxing great, Joe Gans, also of Baltimore. Notice the musculature of his arms, his trim figure, and his thick, wavy hair that is parted in the middle of his scalp. Lyons woolen shorts are looped at the waist by a long kerchief tie, and beneath the shorts he wears tights. The left legging appears to have runs in it, along the inner and outer thigh area. Harry's workout boots, which look as if they are designed for a flat-footed pugilist, might benefit from the more recently developed aerodynamic design features favored by today's athletes. (John Betz Jr., photographer; 415 N. Washington Street, Baltimore, MD.)

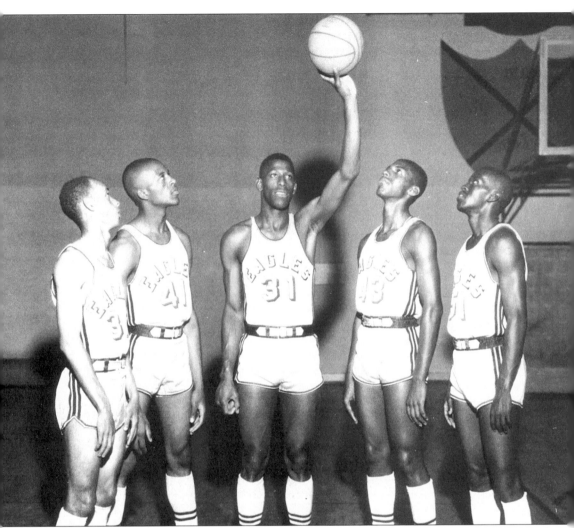

Basketball great Ted Manning hailed from Baltimore and was a 1962 graduate of Carver High School. He starred in the starting lineup of the Eagles of North Carolina College and eventually went on to play for the Carolina Cougars, in the American Basketball Association, in the late 1960s. For several years, Ted was an assistant coach for the NBA's Los Angeles Clippers, while his son, Danny Manning, played for the same team.

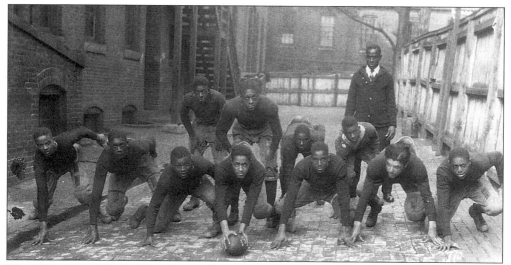

The 1923 Colored High School football team was coached by athletic director Leonard Ulysees "Duck" Gibson, who is standing at the back. By action of the Board of School Commissioners, in this same year the Colored High School was renamed the Frederick Douglass High School. Uniforms and apparatus were often previously used equipment donated by white schools. The football team held practice sessions at Druid Hill Park.

Here, Paul Blair (number six) and Don Buford (number nine) of the Baltimore Orioles are shown presenting a baseball bat to a foreign delegation. In 1970, these two players helped the Orioles to victory over the Cincinnati Reds to win the World Series.

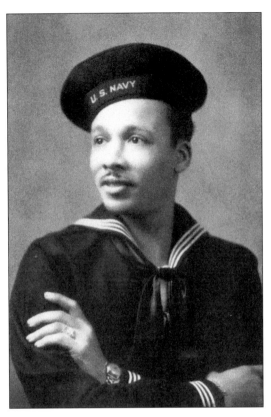

This sailor is Earl Burroughs, who is related to the author by marriage. Here, he poses in his WW II naval uniform. Notice his jewelry: on his right wrist is a bracelet discreetly worn beneath his cuff, and on his left wrist and hand, Earl wears a watch and a large, unusual ring.

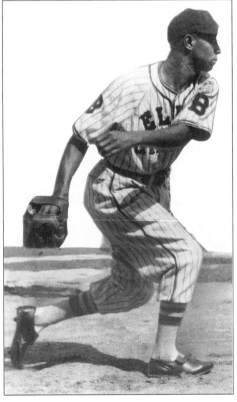

This photograph was taken of Jonas Gaines, a player on the Baltimore Elite Giants, who was featured in the Baltimore *Afro-American* in 1943. The Baltimore Elite Giants beat the Homestead Grays for the 1939 Championship. The Elites, as they were locally called, played in Baltimore from 1938 until 1951. Several major leaguers began their careers with the Baltimore team, including Roy Campanella, Joe Black, and Jim Gilliam, who all went on to play for the Brooklyn Dodgers. Hall of Famer Leon Day played for the 1949 Championship team. Today, more than ever, Negro Baseball League memorabilia is popular, and one can expect to pay top dollar to own a historical piece from the era of black baseball.

This photograph displays one of the many faces of Oliver Johnson, posing here with an early 1920s telephone.

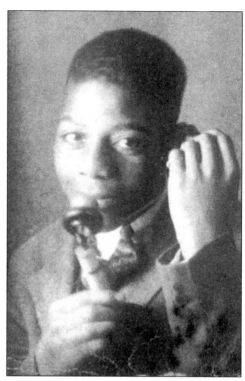

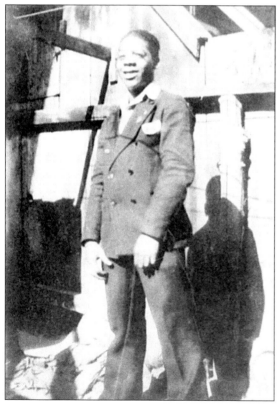

In this April 21, 1928 photograph, Johnson is seen at ease in his backyard.

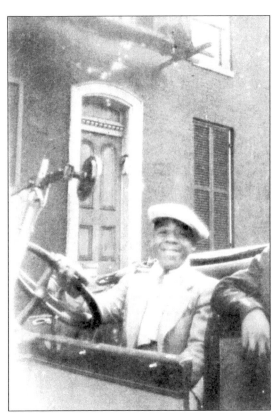

Johnson is depicted here seated in a convertible automobile in front of 12 N. Mount Street on August 1, 1930.

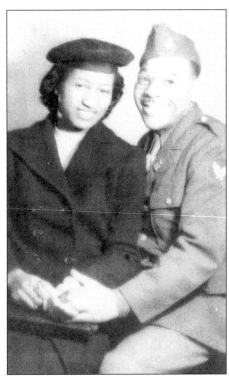

Johnson is pictured with an unidentified woman.

On January 4, 1943, Johnson was photographed dressed in military regalia showing a Buffalo Soldier patch on the arm.

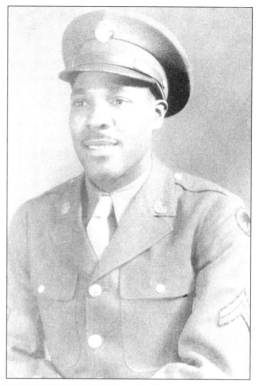

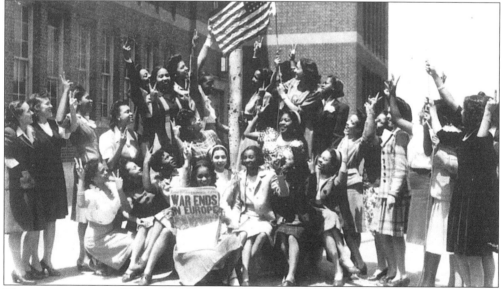

The announcement of WW II ending in Europe threw the American public into a frenzy of camaraderie and exhilaration. In a patriotic gesture, these well-dressed Frederick Douglass High School women celebrate the good news by raising the American flag and flashing the "V" hand sign for victory. The woman perched left of center, at the flagpole, is holding a copy of the Baltimore *Afro-American* newspaper, heralding the end of Nazi terrorism and the return of American troops. The building in the foreground continues to serve today's generation of students at Douglass High School, as it did for these girls in 1945.

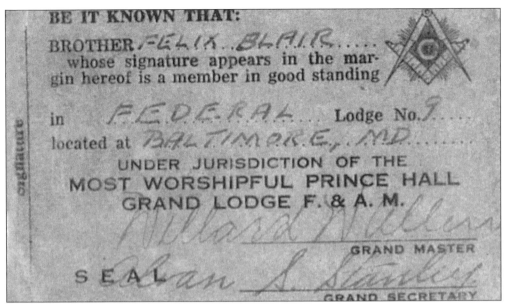

Felix Blair, who was a chef in WW II, was also a member of the Prince Hall Masonic Lodge Number Nine in Baltimore. Pictured here is his 1948 membership card, signed by the then Grand Master Willard W. Allen. Allen had been the grand master since the lodge's inception and has since been succeeded, first by Sam T. Daniels and in 1998, by Grand Master Shelton D. Redden. Felix Blair's wife, Ann, was a successful businesswoman in her own right. She operated several beauty salons around town that catered to both black and white customers. One of Blair's Beauty Salons was located at 1355 North Avenue.

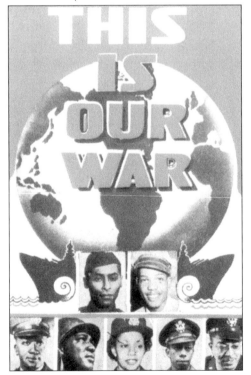

*This is Our War* was published in 1945 by the Afro-American Company. The *Afro* sent six war correspondents on assignment to Europe, to report firsthand on African-American involvement during WW II. The war correspondents included Elizabeth M. Phillips, Herbert M. Frisby, Ollie Stewart, Art Carter, Vincent Tubbs, and Max Johnson.

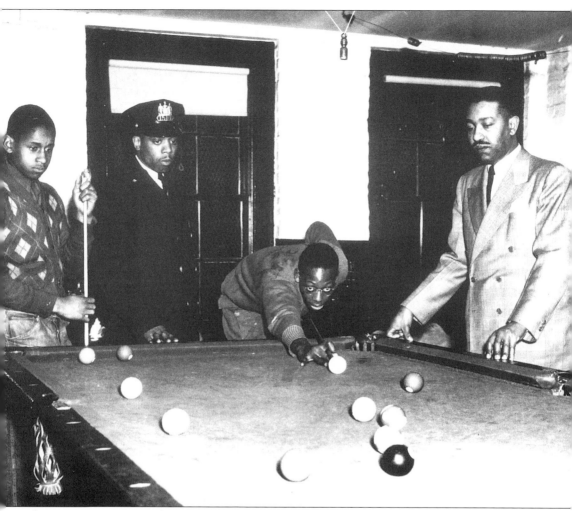

These young men are observed playing a game of pool, which teaches skill and better concentration, and helps build character. This photograph was taken in the spring of 1948. (Jack Engeman Studio, photographer; 701 St. Paul Street, Baltimore, MD.)

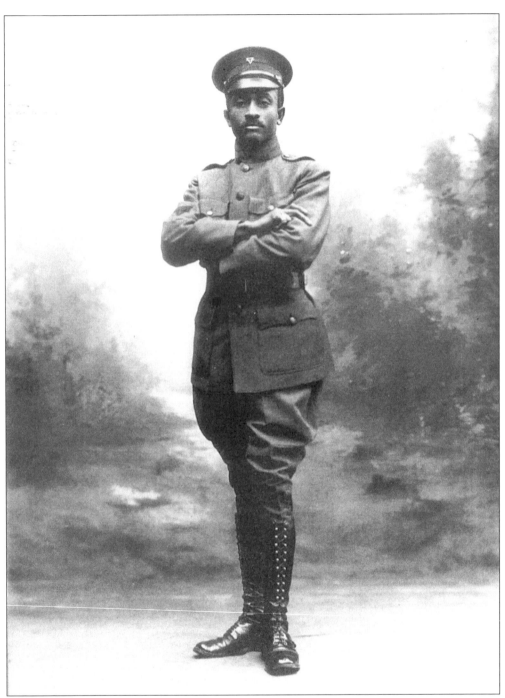

Pictured here, in uniform, is WW I soldier Leonard U. Gibson of the 350th Field Artillery. (See also pages 61 and 91.) Gibson was a Physical Education Secretary with the YMCA (note the YMCA insignia at the front of his cap). Before being sent overseas, Gibson was stationed at Fort Dix, New Jersey. He posed for this photograph in Paris, France. Gibson went on to an illustrious career as longtime coach at Douglass High School. (L. Matthes, photographer; 203 Rue St., Honore.)

## Seven
# INSTANT RELATIVES

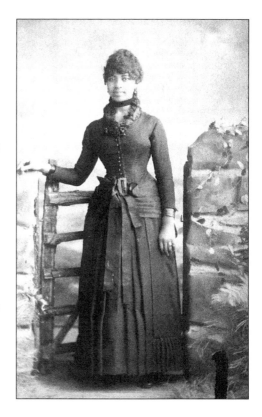

In the antique trade, unidentified images of persons, regardless of their medium, are called "instant relatives." The following images fall into this category and in large part were selected for their appeal based on pose, poise, or period dress. This woman's picture was taken some time between 1882 and 1886. The photographer was Martin L. Robinson, whose studio occupied the third floor of the northeast corner of Eutaw and Lexington Streets in Baltimore. Robinson's business motto was to "provide clients with the best production at the lowest prices." Since its inception in 1871, Robinson's studio was noted for its faithfulness to nature and was unsurpassed in quality by other photographers of his time around the country. By 1886, he had resided in Baltimore for 32 years. The woman in this image is bedecked in jewelry. She is wearing two rings, two bracelets, a choker, and earrings. Her dress features pearl buttons, and she has a fancy bow with an ornamental belt buckle at her waist. Her hair appears to hang in two long plaits on both sides of her neck, just inside the ruffled collar of her dress. There are miniature pleats at the hem of her dress.

Here is an example of the work of an obscure black Baltimorean photographer, John Jones. On the reverse of this picture is written, "Harry Wisher, Mrs. Harriet Wisher, son [sic]."

The photographer caught this man atop his wooden front steps in some disarray. His tie is askew beneath his wide lapelled coat, to which a button is pinned. He appears to be wearing light colored long johns underneath his pants. This man presents a rugged pose with a cigarette hanging out of his mouth and a bowler hat cocked back on his head. As with many old photographs, there is no identifying information on the reverse side of this photograph. Frequently, folks have used the cardboard backing or, in some cases, the front of photographs to calculate mathematical sums or make other notations.

This man, photographed by Maryland Photo and Crayon Company, has on a three-piece, pin-striped suit. His banded collar is also faintly striped, and the composition is broken up by a solid textured bow tie. On the fourth button of his vest hangs a watch fob chain. This picture was taken about 1892, at the studio's location at 644 W. Baltimore Street.

Baltimoreans are famous for sitting on the stoop, especially on fine summer evenings. These people, who sit for the camera on their wooden steps at 1222 Bayard Street, are identified, from left to right, as Berdella, Flessy, and James.

This gentleman posed for photographer James B. Trainor, whose studio was located at 731 W. Baltimore Street from 1888 to 1904. This man wears a stylish cravat (wide tie), which is the focal point of his dress and contrasts his striped, high-collared shirt. The single-breasted coat he wears is cut away at the front like mock "tails," and his pants are rolled up at the bottom rather than cuffed. His overall look is complemented by a chapeau (hat).

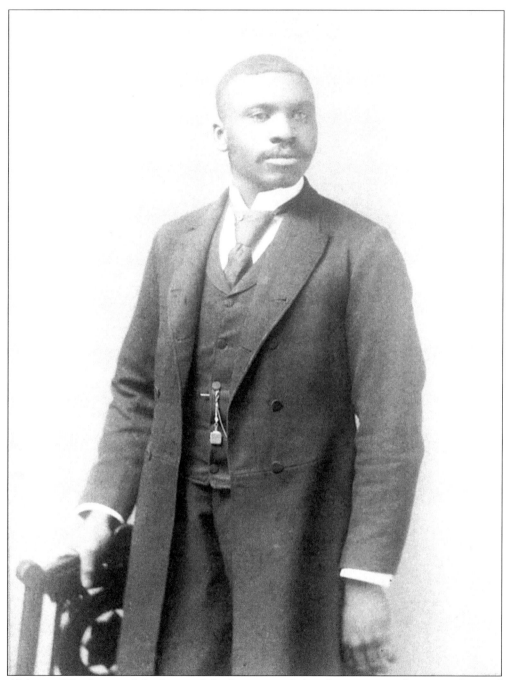

Alphonse Wertheim, of the Imperial Studio, snapped this shot sometime between 1892 and 1895 on his premises at 21 E. Baltimore Street. Consistent with the fashion of the time, this man poses in a three-piece suit. His jacket is long and falls to knee length, while the lapels are cut high on the chest. There is a watch fob chain appended to his five-button vest. In a different style from other pictures of the same period, this man's tie was wide, with a button in the top right corner. Standing before an ornately backed chair, this gentleman exudes self-assurance and dignity.

This type of photograph is termed a "Carte de Visite" or "CDV." The young child seated on a stool in this picture is exquisitely outfitted in a lace dress with ruffled sleeves. Although faint, this sepia-toned image shows that her dress has bows at the shoulders and that she wears a necklace. This image was photographed by M. Stahn, an advertised ambrotypist and photographer at 87 N. Gay Street, Baltimore. Stahn occupied this space from 1865 to 1886. On the back of this picture is written "Mrs. Sarah Colwell, 770 Chestnut Alley."

This image, taken in the 1950s, shows a woman with a young child sitting on her lap. They were photographed at the Williams Studio, located at 1500 Pennsylvania Avenue. It is said that fashion works in cycles, and her dress is comparable to the standard of Sunday dress or office attire worn by women of today. She is adorned with the traditional matching earrings and necklace set, complemented by a chic, sculpted "modern" hairstyle. It is interesting that the child's attention is focused in the opposite direction from the mother's. The child is dressed like the mother, down to her necklace and the ring on her left ring finger.

These light-complexioned women, appearing in affluent dress, concentrate on a bunch of freshly picked roses. Their hair, leather shoes, and fur-trimmed coats are in complete contrast to this bare cobbled backyard setting. Note the younger woman's drop earring and the "busy" hand-crafted chair back on which she sits. This picture was taken in the 1920s by Penn Studio.

This well-dressed young girl enjoys a day in the sun in front of her house steps, clutching what we would describe today as an "ethnically correct" doll and dragging a toy along the ground. Note how her hair appears to be fashioned in the style of Caucasian hair, and she is wearing checkered socks and leather shoes. This picture was taken c. 1920s.

Here is an example of an oversized tintype photograph (6 1/2" x 8 1/2" inches) that has been hand painted. The image of this young girl is remarkable for the attention to detail given to her dress, the rose she is holding, and her facial expression. The usual tintypes crafted by photographers were sized 2 1/2" x 3 1/2" inches. Journeymen photographers used this format to take pictures because it was affordable to produce, required little equipment, and no negatives were necessary. Tintypes are also called ferrotypes, or melainotypes, and were used extensively from the mid-1850s to the early 1900s.

This woman is superbly dressed in a blouse of lavish lace. In this picture taken around the turn of the century, she is wearing an elaborate choker, gold necklace, and a "no nonsense" rolled hairstyle, befitting a school marm. This picture was taken by John Jones, a black photographer from Baltimore.

*Eight*
# LIFESTYLES

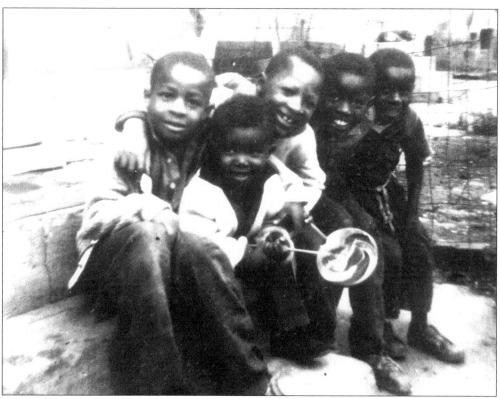

These five little rascals are sitting in the back yard of 1307 N. Stockton Street, in the Sandtown-Winchester district of West Baltimore. These guys were already in on the scoop with a "one size fits all" lollipop. Holding the candy is none other than the author. To his right is his friend, Angelo. Notice that the boy sitting on the far right wears a makeshift, homemade rope belt and sneakers (without shoelaces) that are bigger than his feet. The house on Stockton Street was later bulldozed to make way for more modern row houses. This photograph was taken about 1965.

Mrs. Florence C. Sparrow, Prop.     ANNAPOLIS 5088     J. Alexander Wiseman, Mgr.

# SPARROW'S BEACH
"MARYLAND'S FINEST"

### THE SEASIDE PLAYGROUND OF THE NATION
# ANNAPOLIS, MARYLAND
P. O. BOX 266

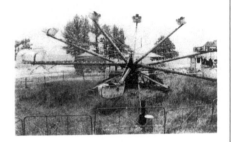

Opening May 15th          Closing September 11th

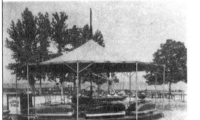

My dear Pastor and Friends:

    How soon may we have the pleasure of again assisting you with your arrangements for a wonderful outing here on the Beach? In our long years of service we have ever striven to satisfy. For this reason, we do not hesitate to invite you to week ends and vacation days with us.

    We do not boast a "Holidays Paradise", but for clean fun, undisturbed relaxation, and healthful play on the Beach and on the Rides, we are sure you can't fin better elsewhere.

    We have tried to show in pictures our many offerings. Space will not permit good treatment. One great writer said "You've got to come and see it for yourself"

    Why not book your outings NOW? We will assure you every possible consideration. Write or call at any time. We are ALWAYS here.

                             Sincerely yours,
                             Management

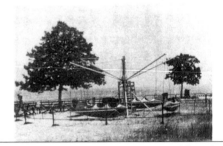

During the days of segregation, African Americans in the Baltimore area frequented beaches and amusement parks such as Brown's Grove, Highland Beach, Carr's Beach, Twin Pines, and Sparrow's Beach. While this flyer describes the activities at Sparrow's Beach, it is illustrative of the rides the public could enjoy at other recreation sites. Patrons could also play basketball, baseball, run in track meets, swim, read, or take a picnic basket for the day's outing. Church groups, fraternities, sororities, and other circles booked passages to Sparrow's Beach.

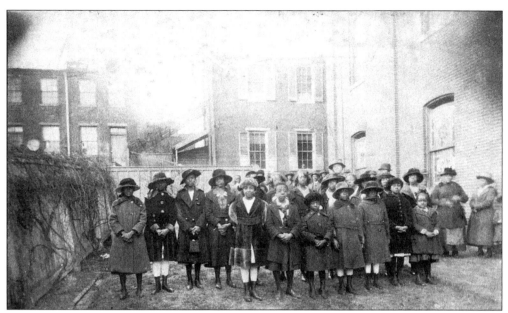

Historically, Baltimore has been fertile territory for professional black photographers. A few of the better-known artists are Paul Henderson, Arthur L. MacBeth, and E.G. Lane. Here is an example of the work of a talented, but lesser known, photographer named E. Victor Wright, in the 1920s. At one point, Wright's studio was located at the Morgan Building (902 N. Eutaw Street, on the corner with Biddle Street), before he eventually moved to 1629 Druid Hill Avenue. Wright took several pictures documenting and preserving images of Douglass High School students. This is an unidentified school group in Baltimore, standing in a yard. Dressed in winter garments, such as coats, hats, and boots, they are ready to combat the elements.

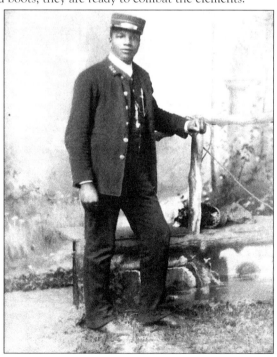

Photographer John Holyland took this rare and outstanding image of an unidentified African-American Baltimore & Ohio Railway worker. Standing in a proud stance, this man has an interesting array of chains on his vest, one of which appears to be a watch fob. The buttons on his uniform are embossed with the company coat of arms, and on his hat is the identification "porter." On his jacket lapel are the initials "B. & O." This photograph was taken some time between 1887 and 1889, when Holyland kept a studio at 3 West Baltimore Street.

Captain George Brown first arrived in Baltimore in the 1890s. Penniless, but filled with big dreams, he apprenticed in several vocations while saving $1,500, which he put toward the purchase of charter privileges on the steamer *Dr. J.W. Newbill*. From such meager beginnings, Brown built a steamship empire that prospered for almost three decades, and was purported to have transported an amazing 3.5 million people up and down the Chesapeake Bay.

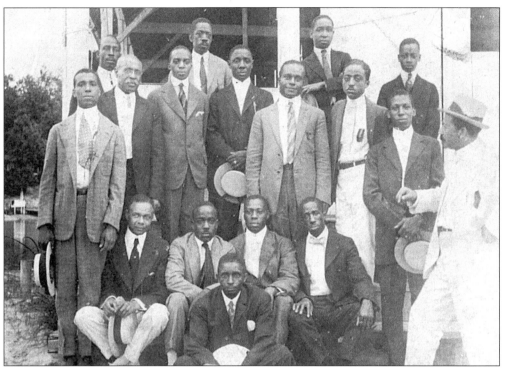

This picture of distinguished gents, taken by photographer Early G. Lane, is believed to show Captain George Brown (wearing all white) at Browns Grove. Note his authoritative stance despite facing away from the camera lens. Also, the men have straw boaters (hats), which at the time were an essential part of summer attire. Captain Brown was the first black to become a member of the Masters', Mates', and Pilots' Association.

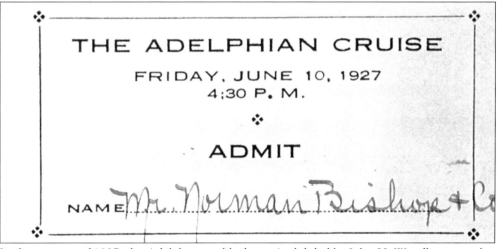

In the summer of 1927, the Adelphians, a black men's club led by John H. Woodhouse, took a cruise along the eastern seaboard on one of Captain Brown's steamships. Pictured is an admission ticket belonging to "Mr. Norman Bishop and Co." Brown owned and operated several vessels during his career, including the *Granite City*, *Avalon*, and *Starlight*, just to name a few. His largest ship could hold up to 1,500 passengers. In 1935, John W. Woodhouse lived at 537 Presstman Street in Baltimore.

There were many black socialite circles operating in Baltimore City for both men and women, one of which was the "Girl Friends." Each group varied in size, house rules, and purpose; some raised funds for charitable causes. Just as criteria existed for college students to enter sororities and fraternities, some elite social clubs were open only to "high yella" (fair-skinned), college educated, or wealthy blacks. Many of the clubs have declined over the years due to members moving or dying, and to a lack of new recruits. Several groups were formed for the purpose of playing cards, shopping, dancing, and/or travel. Some of the clubs' names were Colored Empty Stocking, Fresh Air Circle, Trinity Culture Club, Dubose Circle, Eva Jennifer Neighborhood Club, Whozits, Clever Kiquejays, Golden Rod Pleasure Social, Tee-Tar-Tee, Pastimers, and the Alpha Wives Club.

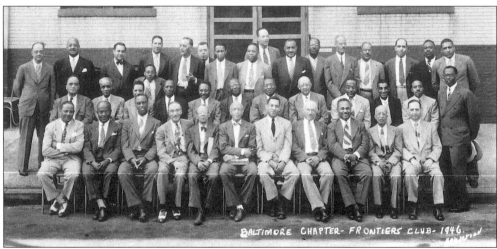

The Frontiers Club is a long-standing organization that is still in existence today. It was created by and for men of the community of high moral turpitude, social fiber, and professional excellence. This 1946 picture features many prominent citizens of the day, including Walter T. Dixon (front row, center), educator and politician; Harry T. Pratt (front row, fourth from right), principal of Douglass High School 1934–1945; and Henry Parks (second row, third from right), owner of Parks' Sausage Company. This picture was taken by black photographer Paul Henderson, who worked for the Baltimore *Afro-American* for many years.

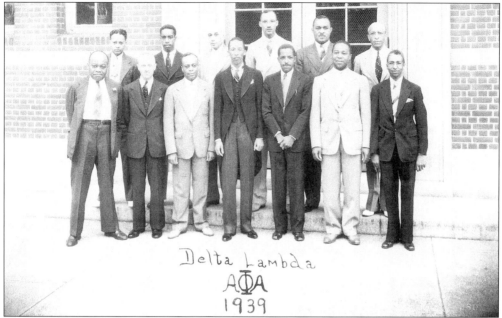

This picture, taken by prominent black photographer Paul Henderson, is of the 1939 Baltimore Chapter of the Alpha Phi Alpha Fraternity, Delta Lambda Chapter. Founded at Cornell University in 1906, the fraternity's current headquarters is in Baltimore at 2313 St. Paul Street. The Fraternity archives are housed at Howard University, where the ongoing progress of successful Alpha men are duly tabulated and preserved as part of the organization's proud history. Alpha men pictured are, from left to right, as follows: (front row) Milton Calloway, educator at Morgan College; Miles W. Conner, president of Coppin State College; Furman Templeton, head of the Baltimore Urban League; (back row) Walter T. Dixon, educator, politician, and co-founder of Cortez W. Peters Business School (Baltimore).

Joe's Pool Parlor was located at 1303 Pennsylvania Avenue. It was flanked on one side by the black photography studio, Lincoln Studio (pictured). In 1952, the parlor was raided by police hoping to capture persons involved in running numbers, based on a tip given to police by a jailed bookie. Note the posters in the window advertising a basketball tournament, a concert to be given by Ella Fitzgerald, and 5¢ Coca-Cola. Reflected in Lincoln's window is Shaffer's Cut Rate Liquor neon sign.

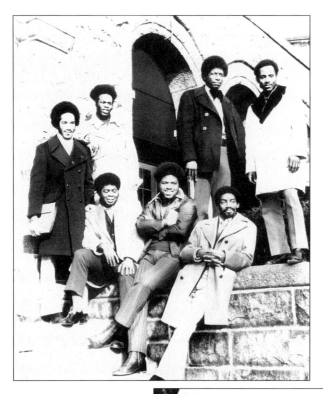

Thank goodness, sometimes change is good! The fashion statements of these men clearly reflected the influence of the "black and proud, say it loud" movement of the 1960s and the early 1970s. Note the influence of black exploitation movies such as *Shaft* (starring Richard Roundtree), reflected in the wide fur coat collars, striped pants, leather boots, and manicured "fros." Right on, right on!

Betsy the Duck and a menagerie of other animals were family pets housed in the backyard of the author's first home on Stockton Street, in West Baltimore. School classes would come from Public School Number 112 to see Betsy and her friends. Among Betsy's colleagues were chickens cooped in a makeshift cage behind the table, a rooster, Peter the Rabbit (who had his own hutch), a cat, and a dog. Betsy lived many long years as a beloved family member.

The man on the left is the author's uncle, William Burroughs (my Aunt Florence's husband). A WW II veteran, Uncle Bill was a jack of all trades: an able carpenter, huckster, handyman, and at one time, a cremator. Here he stands next to a stylish, unidentified man with a cigarette in hand. They may be dressed from head to toe, but they both could use a shoeshine.

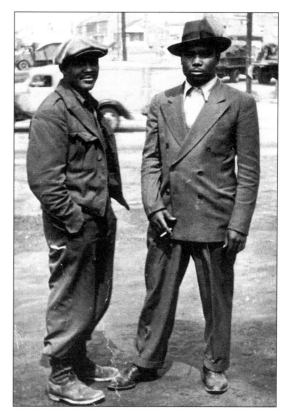

These "quadruplets" are dressed identically and stand before the Penn-Dol Drug Store. This white-owned business was the first store on Pennsylvania Avenue to hire an all-colored staff. This picture, taken in the 1930s, shows Penn-Dol's sign hanging above an advertisement for Western Union. Penn-Dol has since moved across the street from the site pictured here. The Zion A.M.E. Church now stands on Penn-Dol's former site. These women were associated with the Cortez W. Peters Business School. The woman at the far right is pictured on page 47 with Evelyn Wilkey, the longtime registrar at the Peters School.

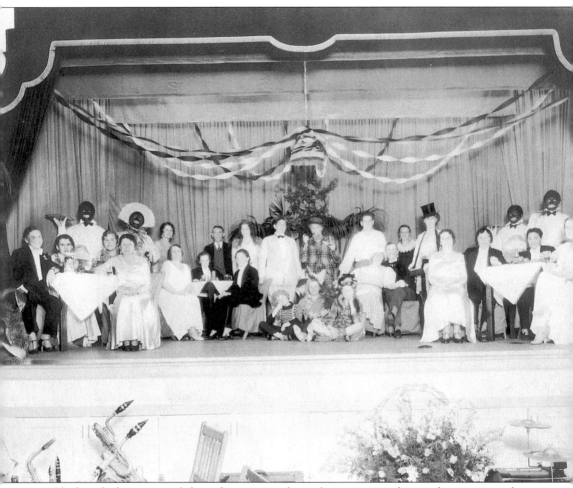

Black and white minstrel shows have enjoyed popularity among white audiences since the pre-Civil War period, largely because of the derogatory and stereotypical jokes directed at black people. This revue party on stage illustrates the subservient roles in which African Americans have typically been cast by white society. For example, there are four white actors presented here in "burnt cork" (black face) portraying a mammy and three waiters. Black actors, during the early 1900s such as Bert Williams and George Walker, had their talents stifled, as blacks were only hired to play caricatures of themselves in black face. Wherever this affair was played, it received a lot of attention with ribbons festooned from the stage ceiling, elaborate flower arrangements, and the orchestra pit with band members' instruments. (Blue Bird Studios, photographer; E. Baltimore Street.)

During the 1880s, McCulloh Street in Baltimore City was a predominantly white residential area. Shortly after the turn of the century, an increasing number of professional African Americans populated the neighborhood. The homes pictured here have since disappeared, and lost for all time are the magnificent buildings, synonymous with the evolution of Baltimorean architecture. Notice the cobble-stone street and wrought-iron railings, which were part of the attraction of these homes. The address shown is 1303 McCulloh Street, on the corner of Lanvale Street.

Pictured here is the old pump house at Druid Hill Park, before it underwent renovations in 1924. The pump house was used to fill the Druid Hill Swimming Pool with chlorinated water. Today, neither the pump house nor the tower remain.

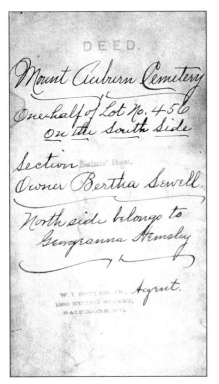

Mt. Auburn Cemetery was dedicated as a Baltimore City Historic landmark in 1986. Notable people such as Joe Gans, W. Ashbie Hawkins, John H. Murphy, Lillie Carroll Jackson, as well as former slaves are buried here. The cemetery has undergone name changes such as the Sharp Street Cemetery and The City of the Dead for Colored People. In 1872, The Reverend James Peck and other trustees of the Sharp Street Church established the cemetery, which is located in the Westport community known as Mt. Winans.

Since the eighteenth century, fraternal (or mutual benefit) societies were founded by free African Americans to pool funds to help alleviate travesties suffered by less fortunate blacks, to foster leadership, and to encourage the social and intellectual development of its members.

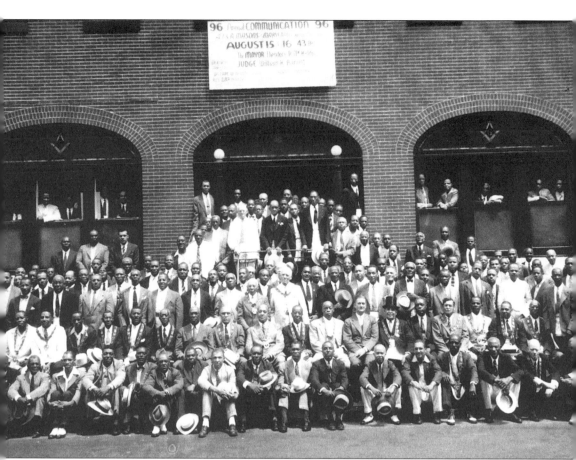

The Prince Hall Masonic Lodge in Baltimore is one such organization that still exists today. Others included the Nazarites (founded 1854); the Good Samaritans; the Galilean Fisherman (founded in Baltimore in 1856); United Order of True Reformers (founded in 1881, in Richmond, Virginia); Grand Order of Good Hope; Knights of Templar; Improved Benevolent Protective Order of Elks of the World (founded in 1899, in Cincinnati); Independent Order of St. Luke; The Knights of Pythias of North America, South America, Europe, Asia, Africa and Australia (founded on February 19, 1864, in Washington DC); and the Knights of Pythias of the Eastern and Western Hemisphere (founded in 1889).

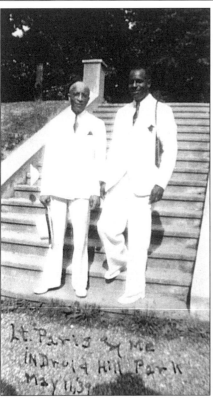

Druid Hill Park was the place people went to be seen on weekends in their Sunday best, as evidenced in these images. Pictured in all their finery are Olivia and Walter T. Dixon, with friend Lieutenant Leon Paris. Lieutenant Paris was an accomplished pilot who had the luxury of owning his own plane.

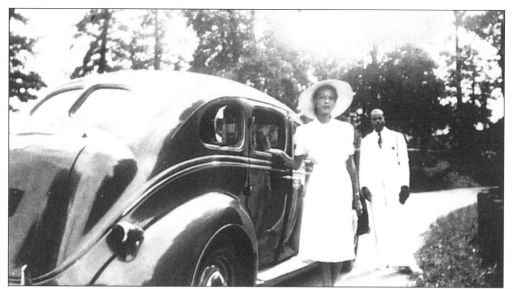

Olivia P. Dixon and Lieutenant Leon Paris are shown at Druid Hill Park, after attending a Sunday church service. The car next to them dates this picture.

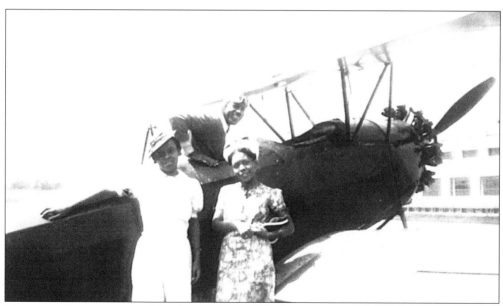

Lieutenant Paris was one of the first recognized black aviators in Baltimore. He lived at 1610 Druid Hill Avenue in Baltimore. It is thought that he flew to France often to visit friends. Here, he poses with daughters of the prominent attorney George W.F. McMechen, while seated in the cockpit of his plane.

**SENT TO JAIL FOR ACTION—No. 2**

State of Maryland, Baltimore City, to wit:

To the Warden of Baltimore City Jail—GREETING:

YOU ARE HEREBY COMMANDED To Receive from any officer the body of *William Jackson col.* who is charged on the oath of *Jacob Bloomberg* with *Larceny of one pair of shoes, valued $5.00, property of the said Jacob Bloomberg* in Baltimore City, State of Maryland, on or about the *17th* day of *June*, 1920. Hearing had, and he was in default of $ *250.00* Bail. COMMITTED for the action of the Criminal Court of Baltimore City, and have the said *William Jackson col.* safely keep in your jail and custody until he shall be thence delivered according to law. Hereof fail not at your peril.

WITNESS, The Subscriber, a Police Justice of said State, in and for the city aforesaid, who hath hereto set his hand and seal this *18* day of *June*, 1920.

*True copy & Test*
*Harry C. Martin Clerk*    *Paul Johanessen* J. P. (Seal)
*Bernard Lee Warden*       *Central* District.

Form 8 to be used for "Partial Hearings" and "Commitment for Further Hearings."

On June 17, 1920, a colored man named William Jackson was jailed for allegedly stealing a pair of shoes belonging to a white man, Jacob Bloomberg. The incident was witnessed by Officer Thomas Garner of the Central District. Bail was originally set at $500, but the day after Jackson's hearing, it was reduced to $250. Had Jackson known that he would land bail of $250, five-thousand percent more than the value of the stolen goods ($5), he might have thought twice before committing the crime! The clerk of the court who certified the note was Harry C. Martin. Bernard J. Lee was the warden to whose custody Jackson was committed.

Historically, African Americans have dealt with discrimination based on the color of a man or woman's skin. Looking at this photograph, it is difficult to know whether the man with the cane is a Caucasian, or an African American passing for a white man. In this picture, the man's pose could be viewed as condescending, with his hand placed on the young black boy's head. But what if this man is a fair-skinned African American? Would his pose therefore be perceived as less emasculating to black society?

This remarkable image captures a football game in action at Druid Hill Park. None of the players are dressed in helmets or other visible protective gear. At least six white spectators are looking on. The vegetation in the background adds a healthful backdrop to this scene. Nowadays, the trees have somewhat diminished due to increased pollution from traffic and natural erosion. This photograph was taken by Chas T. Walter of the American View Company located at 288 N. Charles Street in Baltimore. Walter operated his business from this address from 1900–1904.

In 1963, unemployment for blacks was at 11% compared to 6% for whites. A. Philip Randolph, Bayard Rustin, and others organized the 1963 March on Washington, attended by about 250,000 people, which was at that time the largest demonstration in the nation's history. Demonstrators came from all parts of the country to urge passage of President John F. Kennedy's Civil Rights Bill, which was then being debated in Congress. The Reverend Dr. Martin Luther King Jr. delivered his now classic "I Have a Dream" speech on this occasion.

### MARCH ON WASHINGTON FOR JOBS AND FREEDOM
#### AUGUST 28, 1963

#### LINCOLN MEMORIAL PROGRAM

| | | |
|---|---|---|
| 1. | The National Anthem | Led by Marian Anderson. |
| 2. | Invocation | The Very Rev. Patrick O'Boyle, *Archbishop of Washington*. |
| 3. | Opening Remarks | A. Philip Randolph, *Director March on Washington for Jobs and Freedom*. |
| 4. | Remarks | Dr. Eugene Carson Blake, *Stated Clerk, United Presbyterian Church of the U.S.A.; Vice Chairman, Commission on Race Relations of the National Council of Churches of Christ in America*. |
| 5. | Tribute to Negro Women Fighters for Freedom<br>Daisy Bates<br>Diane Nash Bevel<br>Mrs. Medgar Evers<br>Mrs. Herbert Lee<br>Rosa Parks<br>Gloria Richardson | Mrs. Medgar Evers |
| 6. | Remarks | John Lewis, *National Chairman, Student Nonviolent Coordinating Committee*. |
| 7. | Remarks | Walter Reuther, *President, United Automobile, Aerospace and Agricultural Implement Workers of America, AFL-CIO; Chairman, Industrial Union Department, AFL-CIO*. |
| 8. | Remarks | James Farmer, *National Director, Congress of Racial Equality*. |
| 9. | Selection | Eva Jessye Choir |
| 10. | Prayer | Rabbi Uri Miller, *President Synagogue Council of America*. |
| 11. | Remarks | Whitney M. Young, Jr., *Executive Director, National Urban League*. |
| 12. | Remarks | Mathew Ahmann, *Executive Director, National Catholic Conference for Interracial Justice*. |
| 13. | Remarks | Roy Wilkins, *Executive Secretary, National Association for the Advancement of Colored People*. |
| 14. | Selection | Miss Mahalia Jackson |
| 15. | Remarks | Rabbi Joachim Prinz, *President American Jewish Congress*. |
| 16. | Remarks | The Rev. Dr. Martin Luther King, Jr., *President, Southern Christian Leadership Conference*. |
| 17. | The Pledge | A. Philip Randolph |
| 18. | Benediction | Dr. Benjamin E. Mays, *President, Morehouse College* |

**"WE SHALL OVERCOME"**

### WHAT WE DEMAND*

1. Comprehensive and effective *civil rights legislation* from the present Congress—without compromise or filibuster—to guarantee all Americans

> access to all public accommodations
> decent housing
> adequate and integrated education
> the right to vote

2. Withholding of Federal funds from all programs in which discrimination exists.

3. *Desegregation* of all school districts in 1963.

4. Enforcement of the *Fourteenth Amendment*—reducing Congressional representation of states where citizens are disfranchised.

5. A new *Executive Order* banning discrimination in all housing supported by federal funds.

6. Authority for the Attorney General to institute *injunctive suits* when any constitutional right is violated.

7. A massive federal program to train and place all unemployed workers—Negro and white—on meaningful and dignified jobs at decent wages.

8. A national *minimum wage* act that will give all Americans a decent standard of living. (Government surveys show that anything less than $2.00 an hour fails to do this.)

9. A broadened *Fair Labor Standards Act* to include all areas of employment which are presently excluded.

10. A federal *Fair Employment Practices Act* barring discrimination by federal, state, and municipal governments, and by employers, contractors, employment agencies, and trade unions.

*Support of the March does not necessarily indicate endorsement of every demand listed. Some organizations have not had an opportunity to take an official position on all of the demands advocated here.

The March on Washington bus fare for a round-trip ticket between Baltimore and Washington, D.C., was only $2 (including tax). This button was worn by attendees and was intended as a memento of this important occasion in American history.

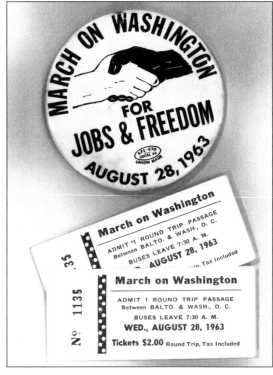